Dedicated to the memory of Frederic H. (Eric) Douglas former director and curator of American Indian Art and Native Arts of the Denver Art Museum.

Table of Contents

Part I: General Principles

Part II: Construction Notes

Foreword

Everywhere in this country people in small museums seem to be hungry for specific and helpful information about how to assemble and care for the collections which they need, and even hungrier for information about how to exhibit these collections most effectively. Yet, in the face of this often-expressed need, relatively little has been put into print on the subject. There have been occasional papers presented at national and regional meetings, occasional seminars and workshops which reached a few people in a few areas, and occasional articles, usually in journals of modest circulation. Now, after two decades of experience, Arminta Neal has addressed herself to this book about the problem.

She is a remarkable person. I have heard someone else say of her (and justly) that she is the only museum designer he knows who takes a visitor proudly into a new gallery and says, "See how little we spent here," instead of, "See how much we spent here." She is a better-than-ordinary folk singer, an ingenious technician, a photographic expert both with the camera and in the darkroom, an enthusiastic and effective lecturer, an inventive exhibits designer who knows how to keep the design from overwhelming material exhibited—and a warm and attractive personality with friends all over the country. In addition to her full-time job as exhibits designer for one of the great natural history museums in this country, she has taken on (often out of pure enthusiasm and at real disadvantage to herself) a multitude of formal and informal consultations with smaller museums and even individual exhibitions. No one I know, East or West, is so effective in pointing out that good exhibition is not so much a matter of money as a matter of ingenuity and in isolating and explaining the principles which are basic to the matter.

This book is the outgrowth of a developmental series of professional papers and articles and represents the jelling of ideas that comes with long familiarity. Its pages contain concepts that have been talked over and tried out and taught in a variety of situations; ideas that have turned out to be effective and practical in actual use; and, most important of all, ideas that are within the reach of a small organization, even one without any paid staff. These ideas are, I think, going to meet a wide-spread need among American museums—and not only among the smaller ones.

H.J. Swinney, Director
Adirondack Museum
Blue Mountain Lake, New York

Introduction to the Revised Edition

Help! for the Small Museum first appeared in 1969. It was a collection of papers given at professional meetings over a twenty-year span combined with information included in letters written in response to requests for help. Additional material was added to form the book. At the time, it was the only available book on museum exhibition designed with a "how-to-do-it" approach and was geared specifically to small museums staffed, essentially, by volunteers. It was my hope the information would encourage and assist eager but untrained volunteers to create exhibits with a professional look—that it would de-mystify the exhibit process.

To my pleased surprise, *Help!* found ready acceptance not only in the United States but in other countries as well. From personal contacts, I know it is now used in Great Britain, France, Denmark, Canada, Mexico, Peru, Brazil, Argentina, Australia, Nigeria and India.

This revised edition eliminates some parts of the first edition. The list of suppliers and manufacturers was obsolete six months after initial publication; books and articles have proliferated way beyond the useful publications list. Fortunately, the American Association of Museums, the American Association for State and Local History, and the Office of Museum Programs of the Smithsonian Institution now provide excellent reference materials at very reasonable costs.

Other materials have been added. Detailed drawings of a versatile panel system are new as are drawings of requirements for handicapped access. A list of regional conservation centers will help people in small museums know where to go for information about how to protect the objects they are using in their exhibits. My apologies go to my overseas colleagues—dimensions are still given in feet and inches because of my continuing "illiteracy" in the metric system.

Some philosophical text is new, reflecting my own growth over the past fifteen years.

As with the earlier publication, I hope this edition helps people to understand that good sense combined with a spark of imagination can be the basis for attractive exhibits. Money has little to do with good, effective design.

Readers probably will notice one more change. In order to reflect the 1980 census finding that there are more women in the country than men, and my own sense that more women are involved in the work of small museums (a feeling for which I must admit I have no supporting statistics), the generic "she" is used throughout the text. This in no way excludes the men who also are a vital part of our museum profession. For me, it is easier to use "she" than the awkward "s/he."

We are all *one*, anyway.

Arminta Neal

Introduction and Acknowledgments
(Revised from 1969 edition)

In October 1955 a slide lecture, "Gallery and Case Exhibit Design," was prepared by the author for the Ohio State Historical Society. The lecture later was published in mimeographed form and was soon out of print. Reprinting by the Ohio Society and the *Clearinghouse Newsletter* for Western Museums was followed by revision and publication in *Curator*. Throughout the years, additional articles were presented at various workshops and conferences and in professional journals. In 1966, all articles were collected into one mimeographed booklet, *Help! for Small Museums*. This collection was out of print by 1968. The present book represents an extensive re-writing and expansion.

While the original articles were developed specifically with the small museum in mind (those with low budgets and staffed essentially by volunteers), the principles apply equally to larger institutions.

The writer is grateful to *Curator* (published by the American Museum of Natural History) for permission to reprint material presented in the articles "Gallery and Case Exhibit Design" and "Function of Display: Regional Museums" which appeared in that quarterly in Vol. VI, No. 1, 1963, and Vol. VIII, No. 3, 1965. She also wishes to express thanks to *History News* (monthly newsletter of the American Association for State and Local History) for permission to include materials published as their Technical Leaflets Nos. 22 and 23.

Many people have provided assistance and encouragement in the preparation of the original articles and the resulting publications and the writer wishes to thank: William T. Alderson, Robert L. Akerley, Stephan F. de Borhegyi, Frederick J. Dockstader, J. Keever Greer, Carl Guthe, Richard S. Hagen, Louise C. Harrison, Eugene Kingman, G. Carroll Lindsay, Alice Marriott, William Marshall, Hugo Rodeck, Clement Silvestro, H.J. Swinney, Harry Shapiro, Stanley Sohl, and Marvin Tong.

What is a small museum?

"Small Museums:

50% love

40% imagination

10% money"

"A museum with a specific or regionally or locally defined purpose usually with small donated collections in need of much conservation and interpretation. Usually has only one poorly paid staff member and most of the budget goes for utilities and maintenance and little for exhibits and education."

definitions from workshop participants

Part I:

GENERAL PRINCIPLES

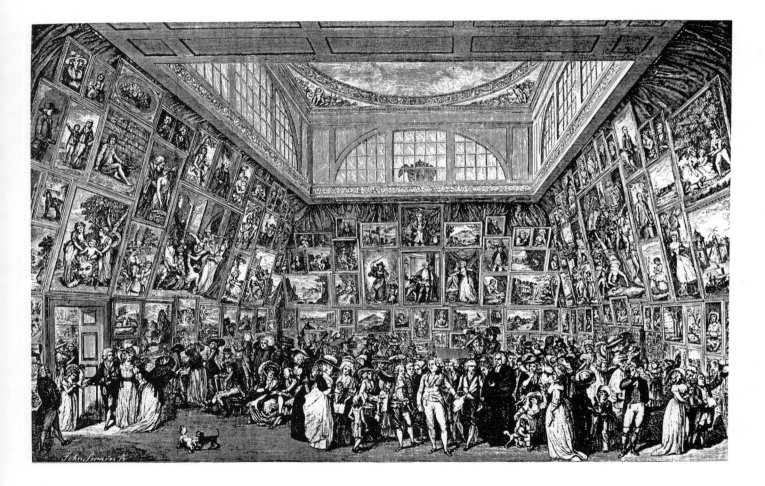

INTRODUCTION: A Brief History of Exhibition

A 1968 magazine article discusses statistics of interest to the museum profession which were compiled originally by the Bureau of Outdoor Recreation Survey and the Outdoor Recreation Resources Review Commission.[1]

The paper reveals that the number of sightseers in the country in 1965 (some 457 million people) is expected to increase by the year 2000 to 1 billion, 169 million—a gain of 156 percent.

The museum world is also growing by leaps and bounds. The 1985 *Official Museum Directory* lists approximately 6,120 institutions in the United States—up 1,020 from the 1973 directory. New museums open at the astounding rate of one every three and a half days.[2]

Today with travel and television, people are generally better informed about their world and have broader interests than previous generations. They are interested in the "whys" and "hows" of things certainly as much as they are in the "whats"—and by the "whats" I mean the objects in museum collections.

In older days when communications were slow—when it took a long time to go from "here" to "there"—most folks didn't travel and the curiosities of the world, the *objects* of collections, commanded great interest. Scientific knowledge about the world was increasing rapidly and expeditions were sent out to explore, collect and return home with as many rare, new, and unclassified specimens as was possible. Sorting out and investigation of the specimens could follow later. The important thing was to collect.

The collecting "instinct" (it might be termed) is an old one. At least 40,000 years ago and perhaps as much as 85,000 years ago, people were collectors, for archaeologists, investigating in the caves of Neanderthal people have found pieces of red ochre, fossil shells and peculiarly-shaped stones.[3] These collections of curiosities possibly represent the oldest known "curio cabinets" as museums in their earliest history have been called.

Early museums often were the private collections of princes, nobles, and wealthy patrons of the arts and sciences and reflected the specialized interests of these people. Seldom open to the public, they were prestige items which one showed off to friends who had the same interests and level of knowledge as the owner/collector—a closed circle of connoiseurs and scholars. Having an extensive gallery or curio cabinet confirmed that the owner had the wealth, position and power either to acquire the objects on personal tours of strange places, or was able to send emissaries on exploring and collecting expeditions. The results of these tours often found their way into the equivalent of a huge trophy room where everything collected was sure to be placed on view.

As Kenneth Hudson[4] has explained, the exclusiveness of museums in relation to the "masses" began to change with the introduction of a series of international exhibitions. These began with the Crystal Palace Great Exhibition in London in 1851. The Centennial Exposition held in Philadelphia in 1876 was such a project. These exhibitions attracted vast numbers of visitors from all walks of life forcing the recognition that the arts and sciences were the proper concern of everyone, regardless of station of life.

Exhibit "design" had not changed much from that of the private collectors. Manufacturers, the main supporters of the international exhibitions, showed as many of their products as was possible, often creating patterns with the objects.

Many museums today, large and small, have not progressed beyond this stage of museum exhibit evolution and are frozen in the suspended animation of display techniques that developed in the late 1700s.

Greatest Butterfly Collection in America

"Ornamental Entomology," 1909

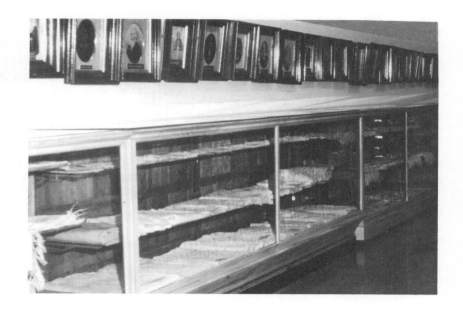

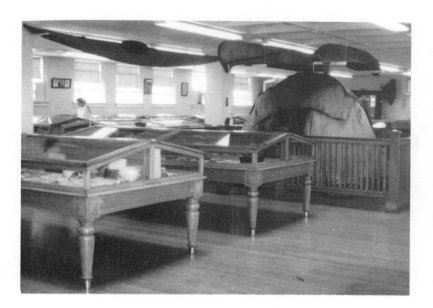

A few years ago I travelled from Denver to the West Coast, to the Mid-West and to the East Coast and in each area it often was possible to anticipate the exhibits of small museums before entering the buildings. I could be sure there would be department-store display cases with glass tops, fronts and sides, and with sliding glass doors at the back. The cases would be lined with glass shelves which would create a series of monotonously repetitive lines in the main room. The quantity of glass surfaces would reflect light from every available source in the room. In one case there would be a collection of china with, in some instances, dinner plates stacked one on top of another. In another there might be twenty to fifty moustache cups, while in yet

another there would be neatly folded linens. Somewhere there would be a table type of case with a scratched glass top and inside would be hundreds of chipped stone points, scrapers, choppers, knives, and hammerstones. Another table case might have some bedraggled stuffed birds (probably from Asia or Africa). Additional cases would be filled with clothing, carpenter's tools, blacksmithing equipment, dentist's picks, a doctor's bag, and old office equipment. Guns would be stacked from floor to ceiling and bullets, cartridge cases, bullet molds and cans of gunpowder (dangerous!) would be on one of the glass shelves in any of the previously mentioned cases. All items would be identified with a typewritten caption on a dusty, fly-specked white index card.

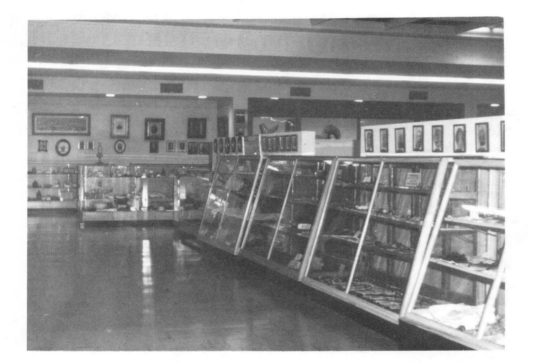

These museums from coast to coast, are exhibiting their materials in what has come to be called the "visible storage" type of display, much like the cans on the shelves of a supermarket. Their efforts often resemble those of department stores, with the glass-topped, glass-sided cases edged with gleaming metal trim resting on rich hardwood bases, aligned in even rows that march across the expanse of the display room. Reflections on the myriad surfaces of glass prevent immediate recognition of the contents of the cases, so that the room becomes a place where the glass display cases themselves are the immediate objects being shown, not the items inside them. Sometimes, the only apparent difference is that in one instance items are accompanied by a price tag and in the other they are accompanied by a donor tag, e.g., "This lace handkerchief carried across the Plains in 1869 by Eliza Brown, donated in loving memory by her granddaughter, Mrs. Edward Smith."

Currently, a few museums are planning galleries that emphasize visible storage displays in an attempt to provide public access to the full collections. Often, catalogue information is available in the form of computer print-out sheets held in three-ring notebooks anchored on centrally placed pedestals. Sometimes these public access galleries include a small section or sections that show "interpretive" (story-telling) exhibits. To my mind, many of these galleries are confusing, not making a clear enough *physical* separation between the visual storage exhibits and the interpretive sequences.

The first function of a museum today is still to collect, document, and preserve those materials within its stated province—be it natural history, history, art, science, or industry. We want to collect the objects representing our history, not only to preserve the nostalgia of time past for older citizens, but to inspire young people with a feeling for history. We want to be able to interest our youngsters in our heritage, but, because they *are* youngsters, they will not understand the objects of history if these are not interpreted. Interpretation provides the meat for the bones of the object. Interpretation fills out the flesh of who, why, where, when, and how of the "what" of the object. Interpretation makes the object come alive in our times, for it can tell us about the people in previous times who have made, worked with, designed, or held the objects we now can see. To feel the exact object in our hands— even just to see it—gives us a handshake across whatever centuries have intervened. We meet the maker, and there's an undeniable thrill in this.

And this, too, is what exhibits really are all about. People. Without people there would be no history—only the quiet winds whispering through the tall grasses of the plains, or the hot breezes blowing sand across a southwestern desert. Without people there would be no objects of pre-history or of history to collect. No bone awls slippery with accumulated years of oily sweat, no finely stitched baskets, no smoothly polished wooden spinning spindles, no finely worked and intricately designed quilts, no finely honed broad axes, no sturdy, smoky pot-bellied stoves. No tools. No clothing. No houses. No towns. People *are* what history collections are all about. People—their hopes, dreams, triumphs and tragedies all reflected in the every-day pieces of their lives. . .the pieces that form museum collections.

And so we come to the second basic function of a museum which is *to select items* **from its collections and, in displaying them,** *organize them into a meaningful story.* Basically there are two kinds of exhibits: one that traces the history of a person, an event, a significant artifact or series of artifacts; one that shows many objects in a comparative way. The first is a linear, sequential *story*, often a "permanent" exhibit. (Permanent is in quotes because nothing really is.) The second kind is unstructured, random. . .a "World's Fair" kind of exhibit with little need for a linear presentation. Craft shows or exhibits of many types of one thing might be arranged this way. This type of exhibit most often is a temporary or changing exhibit.

For the small history museum the interpretive function carries with it the responsibility of exhibiting the *local story first* and in depth. This is why people have come to the museum—to learn about the area in which it is located, not to see another collection-on-view which may differ only slightly from a collection they have seen the day before in a

different locale. All the components of a collection—the relics, the mineral specimens, business journals, diaries, old guns, natural history specimens—all these things of the local area will, of themselves, tell the visitor little. They *do* provide the raw material on which interpretation is based. They also provide a visual impact on the mind of the viewer, creating concrete and tangible images that are remembered longer than a skillful illustration in a book. But to communicate, this raw material must be adequately arranged and labeled to present a logical sequence.

Some of the questions in the visitors' minds which exhibits can answer are:

> **Where is the town or region;** what is its relationship to the surrounding areas?
>
> **Why is the town where it is?** In the West this question might be answered in a number of ways: "We're where cattle trails crossed; where the railroad ended for ten years before moving on; where Indians camped and trappers came to trade; where a stage station was located on the old Santa Fe or Oregon trails; where prospectors came to search for gold and silver and merchants followed to establish businesses." In the East this question might be answered by one of the following: "We're where a fort was built during the French and Indian War; on a river that was the first 'highway' through the country and a portage was necessary at this point; the coastline made the start of a safe harbor and fishing was good; trade ships from Europe transferred goods here for inland distribution." It might even be answered with "We're where recreational use of the area developed early and people came to enjoy hiking, fishing, hunting, camping, and skiing."

Additional questions to be answered by exhibits are:

> **Who came here first?** Who were the prehistoric people? What Indians were here in early historic times—at the time of contact with non-Indians? How did they live? What food did they eat and how did they get it? How was the food prepared, with what kind of utensils? What kind of houses did they build? What style of clothing did they wear? What kinds of social and political organizations did they have? Who were their enemies before non-Indians appeared on the scene?
>
> **Who were the first non-Indian settlers?** Where did they come from? Why? How many came? Where did they settle first? How many stayed?

Not only should the questions of **where, why,** and **who** be answered by the small museum's exhibits, but also "Why does the town *still* exist?" Is it one that depends upon lumbering or its affiliated industries, pulp, paper, plyboard or chipboard? Is it on the coast with a good harbor and a thriving shipbuilding industry that has changed from making schooners to submarines? Is it a major shipping point for cattle? Is it in the midst of a major recreational area? Museum visitors may be interested in the businesses and industries of the region—their history and development and present-day methods of operation.

Almost always there will be one or more incidents which are unique to the local area represented by the small museum and while they may not have had much bearing on the main course of national history, they are interesting simply as illustrations of how people have faced problems in former times. Use of the objects in collections to help

explain these incidents will aid the visitor to remember a specific museum over others which simply place the materials with others of their kind on the glass shelves in their display cases.

There is, of course, a place for the quantities of so-called duplicate items in any collection. This place is the **Study Collection** from which objects for temporary, changing exhibits may be chosen; other objects rotated with those on permanent display (providing protection for the artifacts.) The study collection also is made available to students and scholars who may need many examples of a given object for comparison in their investigations. Study collections are often arranged much like the stacks in a library and work tables with appropriate lights are provided at regular intervals for the use of research visitors. These research visitors are the ones who will appreciate and use the great masses of materials that are not placed on public display. Written policies must be established which will control who has access to the collections, and how.

Sometimes materials from the study collection may be used to create exhibits that supplement an exhibit brought in from outside—a "travelling" exhibit. This supplemental display can focus on a local aspect of the larger areas covered in the loan or travelling exhibit.

The ultimate aim of any museum exhibit, whether in a large or small institution, should be to stimulate such an interest in the subject that the viewer wishes to learn more about it in her spare time. Sometimes local libraries will cooperate with the museum to provide reading lists which key in with the museum's displays and these are given to interested visitors.

[1] "The Big Leisure-Time Explosion," in *Popular Gardening and Living Outdoors*, Spring 1968, Holt, Rinehart and Winston, Inc.

[2] Schwartz, Alvin, *Museum: The Story of America's Treasure Houses*, E.P. Dutton & Co., Inc. 1967, p. 18.

[3] Leroi-Bourhan, A., *Prehistoric Man*, Philosophical Library, New York, 1957, p. 41.

[4] Hudson, Kenneth, *Museums for the 1980s*, Holmes & Meier Publishers, New York, 1977, p. 8.

Evolution of a Gallery

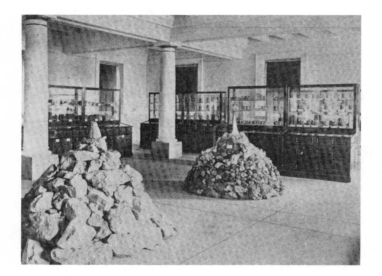

In May 1909, a series of mineral exhibits, housed in the then Colorado Museum of Natural History, was opened to the public.

Denver Municipal Facts, May 22, 1909

By November 1909, additional floor cases had been purchased and installed. The two mineral "pyramids" in the previous picture are barely visible in the back portion of the room.

Denver Municipal Facts, November 13, 1909

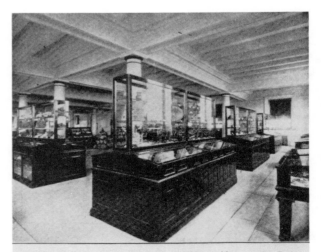

An Interior Showing Arrangement of Curio Cabinets in Museum at City Park.

In the early 1950s the vertical portions of the floor cases had been removed but the floor was still pretty well covered by the "visible storage" kind of exhibit. By this time the name of the institution had changed to the Denver Museum of Natural History.

In the late 1950s the floor cases were removed and a process of selection of materials based on a common theme was under way. Extra specimens were retired to a study collection.

By the early 1960s alcoves with built-in cases were designed to enclose many of the pillars in the room and materials were installed to tell the chronological story of the "Succession of Life."

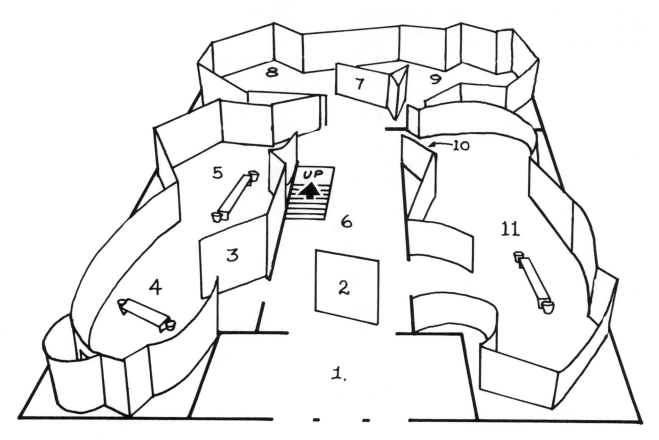

First Floor Plan for Functional Outline of a Museum
(Numbers on the drawing correspond with those in the following outline.)

FUNCTIONAL OUTLINE OF A TYPICAL WESTERN MUSEUM

The following outline illustrates the layout of a medium-sized imaginary museum of history in a non-existent western state which might be organized along the functional interpretive lines just discussed. The concepts of interpretation may be used whether the displays are arranged in alcoves or in a series of separate rooms.

The visitor to our imaginary museum would enter what could be called a reception area (1), with an information desk and an attendant at one side. This reception section could include a small book and gift shop where items appropriate to the exhibits in the museum would be on sale. Across the room could be a checking stand where coats, packages, bundles, briefcases, and other hindrances to the physical comfort of the visitor could be stored safely, without charge. Other facilities immediately apparent and perhaps adjacent to the checking stand, would be a pay telephone, a drinking fountain, and restrooms. Several benches or comfortable chairs with convenient ashtrays placed around the area could provide a meeting place and also a smoking area which would be under the constant supervision of the information attendant. At least one wastebasket should be in this "lobby." Visitors cannot be blamed for dropping trash on the floor if there is no obvious place to deposit the inevitable tissues, gum, and candy wrappers.

11

Directly opposite the entrance, just within a hall leading to the rest of the museum, a large panel (2) reaching, perhaps, from floor to ceiling, could carry a label that might read as follows:

WELCOME!

IN OUR MUSEUM YOU MAY SEE THE STORY OF OUR LOCAL HISTORY. On this floor there are three main display rooms:

 The Natural History Background and the Earliest Inhabitants—the Indians (to the left of the main corridor)

 Early Explorers and Travelers (in the room straight ahead at the end of the hall)

 Permanent Settlements: Development of towns with industries, agriculture, transportation and communication (to the right of the main hall)

Second floor exhibits show the development of our community since the transition from Territory to present-day State.
The Museum also owns extensive study collections of historical objects, photographs and manuscripts which are available to scholars and students upon application.

WE HOPE YOU ENJOY YOUR VISIT

Now the visitor may make a choice. If she is interested primarily in how the early families of the area lived, she can go directly to the third gallery and digest its contents before "museum fatigue" sets in. Let us suppose, however, that she wishes to see the whole story. She proceeds to the first gallery—the one to the left of the main hall.

Just inside its entrance may be another large panel (3) with oversize photographs of landscapes typical of the area. The label might read:

A VARIETY OF LANDFORMS and **ACCOMPANYING CLIMATES** has made it possible for a great number of plants and animals to live in our State since before remembered time. In the earliest days of human occupation, Indians followed the herds of game, and animals and people lived together without competition.

By its position, this panel would direct the visitor into the room (4) where she might find selected exhibits summarizing the main species of plants and animals found in the area. This will be of particular interest if the visitor and her family are camping on their trip. Additional exhibits might trace the development of Indian cultures up to the time of contact with non-native people (5). Several visual techniques could be distributed through the room: relief maps, photographs of plants and animals together with miniature dioramas depicting ecological associations; artifacts, and explanatory panels. The exhibits would stress natural history as the background for the local history, showing for example, how animals trails were followed by later explorers.

Chairs or benches would be so placed as to permit resting while viewing, and at the end of each bench there would be a large wastebasket in which film cartons, Polaroid camera clutter, and other litter could be deposited. Returning to the central hall (6), the visitor would proceed to the second gallery.

Again, an introductory panel (7) would display a very large map of the area with the trails followed by early explorers marked in relation to present-day towns and highways. The label on this panel might read:

SPANISH EXPLORERS CROSSED OUR LAND AS EARLY AS 1604 searching for gold and for new routes to the Pacific Coast. In 1830 the first fur trappers, the famous "Mountain Men," were the first Americans to explore land which, at that time, did not yet belong to the United States.

Exhibits in this section (8) would include detailed maps of the routes of explorers and trappers, displays of such artifacts as would show how the early Spanish soldiers were equipped; artifacts that would, with proper labeling, illustrate the life of the early trappers and explain their methods of trapping, supply and freighting; and cases containing trade goods with labels explaining the value of each in trade—e.g., how many beaver pelts could be secured in exchange for a metal tomahawk.

Additional exhibits (9) would explain the routes and hardships endured by the early American military explorations—groups such as those led by John C. Fremont and Zebulon Pike. Other exhibits would show what emigrant trails, if any, crossed the area.

Finally, on this floor, the visitor would enter the third gallery. Here the introductory panel (10) might have an opening cut into it which might frame a diorama representing a wagon train. The main label would explain:

PERMANENT SETTLEMENT OF OUR AREA BEGAN WHEN EMIGRANTS FROM THE EAST, lured by the prospect of rich farming lands, banded together in wagon trains to make the hazardous trek across the Plains and Mountains.

Exhibits in the gallery (11) might follow an outline such as the following:

THE FIRST ARRIVALS: 1850-1860
Displays might include tools and equipment used during a wagon train trip. Labels might be drawn from various pioneer diaries. A "Who's Who" of daguerreotypes showing some of the early settlers could be included.

EARLY COMMUNITIES
How the People Lived and Worked: Man's Work, Woman's Work
 (could be arranged according to the calendar)
Home Life: Social Life: Home entertainment, Balls, Parties,
 Celebrations (such as Fourth of July)
Schools
Churches
Early Stores and Industries
Indian Troubles
Military Forts and a Soldier's Life

COMMUNICATION WITH THE "OUTSIDE" WORLD
Freight and mail routes; timetables and rates
Pony Express days
Completion of the Transcontinental Telegraph

THE COMING OF THE RAILROAD: A new day of rapid development and the end of Pioneer times. A final display might summarize the reasons for the area's continued existence.

Second floor displays could depict the participation of the community in the Civil War, the Spanish-American War, First and Second World wars, and in the Korean and Vietnam wars; it would also detail the lives of local residents who were important in national affairs. A centrally located room with adjacent restrooms, and a drinking fountain, would again give the visitor an opportunity to relax before continuing the tour of the exhibits.

The central hall or corridor on the first floor (6) would provide space for temporary, changing exhibits. These could be exhibits on loan from other museums or national institutions, or could be exhibits highlighting some local "happening." This would also be the place to have an annual display of children's and hobbyists' collections. **Changing exhibits are important to help attract repeat visits** from the local people.

In all the galleries outlined, a variety of techniques would be used to provide a visual change of pace for the visitor to help counteract inevitable fatigue. These techniques, some of which have already been mentioned, would include:

Panels

Maps

Case openings of various sizes and shapes

Variations in ceiling height and floor levels where possible within structure of building

Change of pace in presentation of very large and very small objects (Conestoga wagon to snuff box)

If the labels accompanying these exhibits are written to convey something of the strengths and weaknesses, sorrows and delights of the people who made and used the objects displayed and also impart the statistical information relating to dates and places, and, if these labels have been kept short and to the point, the visitor may retain some of the idea of sequence and flow of the history of the region and may even be stimulated to pursue some facet of the story in greater depth. If this happens, the *full* function of the museum's displays will have been achieved. For, though educational, the exhibits cannot, from a practical standpoint of observer time involved, explore any one subject in depth.

The exhibits should so excite the visitor that she leaves determined to learn more about a detail that has intrigued her.

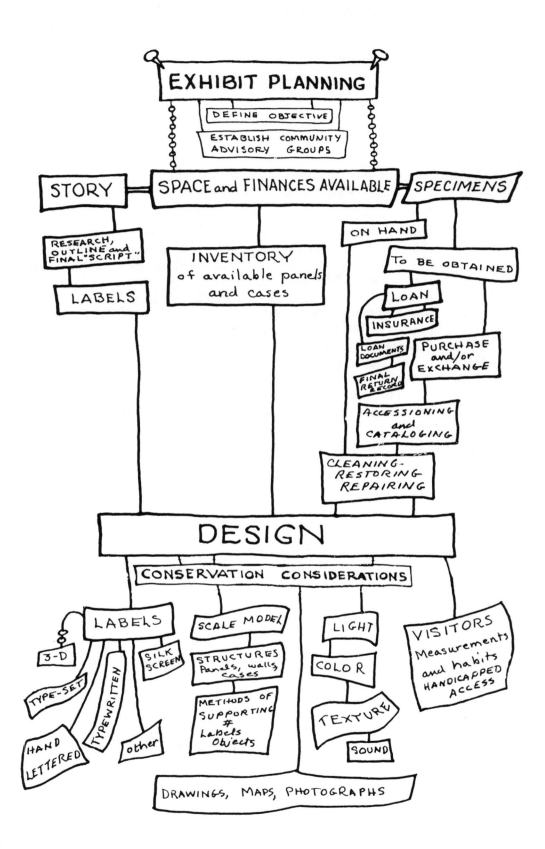

EXHIBIT PLANNING

DEFINE OBJECTIVE

ESTABLISH COMMUNITY ADVISORY GROUPS

STORY

SPACE and FINANCES AVAILABLE

SPECIMENS

RESEARCH, OUTLINE and FINAL "SCRIPT"

LABELS

INVENTORY of available panels and cases

ON HAND

TO BE OBTAINED

LOAN

INSURANCE

LOAN DOCUMENTS

PURCHASE and/or EXCHANGE

FINAL RETURN RECORD

ACCESSIONING and CATALOGING

CLEANING- RESTORING REPAIRING

DESIGN

CONSERVATION CONSIDERATIONS

LABELS

SCALE MODEL

LIGHT

VISITORS Measurements and habits HANDICAPPED ACCESS

3-D

SILK SCREEN

STRUCTURES Panels, walls cases

COLOR

TYPE-SET

TYPEWRITTEN

METHODS OF SUPPORTING # Labels Objects

TEXTURE

HAND LETTERED

other

SOUND

DRAWINGS, MAPS, PHOTOGRAPHS

The Planning Process

Visitors sometimes think the exhibits are all that a museum is about. Not so. Collections are the primary concern; exhibits are just one way of interpreting the objects of the collections. The proportions of space allocated within the museum building should reflect this relative importance. **At least** sixty to seventy percent of the building should be devoted to collection storage, a workshop, office space, and storage for office supplies. This leaves thirty to forty percent of the floor space for exhibits. Of this exhibit area, I feel strongly that thirty percent should be saved for temporary, changing displays. Changing exhibits encourage visits by the local people.

Changing exhibits may be centered on different themes: clothing, farming, food preparation from early times. One temporary exhibit at the Littleton Historical Museum in Colorado was about "The Roaring 20s." A delightful, yet simply designed exhibit, it included everything from washers and cookstoves to flappers' dresses, "baubles, bangles, and beads," sheet music and period newspapers.

The changing/temporary exhibit can also be used to show collections of members of local clubs—the archaeological society, mineral society, doll collectors, railroad, and camera clubs.

And the changing exhibit space can show the collections of children—the stamps and coins, baseball cards, comic books—all organized with the real participation of the youngsters themselves.

NOW. You have created your exhibit **space** and have decided you will build an exhibit. What's next?

Define your objective: What is it you want your visitors to learn or understand better after they have seen the show?

Is an exhibit the best way to present the subject? An exhibit should not be a textbook. An exhibit **should** be made up primarily of objects—artifacts, photos, maps, illustrations and the like—**not** primarily of label texts. If it begins to look as if label texts will dominate, it is time to consider publishing rather than exhibiting.

Who will be involved? Community advisory groups should be created to help with specific exhibits. These would include business people to help with money resources and media people to help with publicity. Certainly, if the exhibit deals in any way with the ethnic groups of the city, advisory groups drawn from these communities should be involved in the project from the earliest planning days.

At the Denver Museum of Natural History, a Native American Advisory Council was established when the museum developed a major hall on historic native Americans north of Mexico. The council had full participation in all planning including veto power over subjects and artifacts they deemed sensitive. Through the council the museum was able to make sure proper purification and dedication ceremonies and rituals were performed by qualified shamans when the council felt this was needed. The council continues to operate in any decisions concerning the native American collection.

In 1976 the Department of Urban Outreach of the Philadelphia Museum of Art announced a series of exhibits which extended over a six-month period. With the basic title, *Rites of Passage*, members of the black, Chinese, Italian, Jewish and Puerto Rican cultural communities worked with the museum staff to interpret the ceremonies and customs

that accompany the passage from one "age" of life to another, e.g. birth, adolescence, marriage, old age and death. The museum staff realized only the members of the different ethnic groups could help define exhibition concept and content in a sensitive, nonexploitive and constructive manner. A detailed account of this highly successful program is "Rites of Passage: A City Celebrates its Variety," by Penny Bach, in the September/October 1976 issue of *Museum News*.

Another advisory group can be made up of teachers—from kindergarten to college—to help develop ideas that will tie closely with curriculum.

And a final suggestion—create advisory groups of **students**—from elementary, middle, high school and college. Let these enthusiastic volunteers really feel as if they are a part of the museum's planning process. Let them install some exhibits **they** have planned and built. They may become some of your most enthusiastic advocates.

Formation of these groups, and their **active** participation, gets the entire community involved in the museum process, helping to destroy the stereotype of the museum as a place only for the elite.

EXHIBIT WORK SEQUENCE

Museum exhibits, whether a single case or an entire hall, essentially are a means of communication. In order to communicate successfully the person planning the exhibit should be thoroughly familiar with the following factors:

1. the idea or story to be told;
2. the objects with which to tell it;
3. the area or space to be devoted to the story (size, dimension, shape of the gallery)
4. an awareness of the audience it is to reach;
5. a knowledge of exhibit structures: panels, platforms, pedestals and cases; a knowledge of building materials and design techniques with which to present the story;

All these are considered with the "givens" of the budget.

THE STORY

The importance of the story to be told has already been emphasized in previous pages. Planning the manner in which the information is to be conveyed (whether a single case or a total gallery is involved) must not be a hit-or-miss effort or just the "lumping" together of similar objects within an area. People who read *Reader's Digest* or a collection of short stories may remember one or two articles or stories vividly but completely forget the remainder. The same people who read a novel—even one that is badly written—will remember the setting, the main characters, their interrelationships, and the plot, for all are tied together in a unit. So must the exhibit be a unit, and the individual parts must contribute to that unit if communication from the specialist to the visitor, via the exhibit, is to be achieved. This is true whether the exhibit flow is to be sequential or random.

The first step toward accomplishing this unification is perhaps the most difficult to take: write a specific and precise outline of the main points to be covered. It is easy for one to speak in general terms and wave one's hands in the air saying, "We'll put the Indian stuff here at the entrance to the hall and about midway we'll put what's left of that old Conestoga wagon to introduce the pioneer section."

But to commit a logical sequence to paper is most difficult. As topics are written down, additional subjects demand attention, and the rearranging of these basic considerations becomes a disagreeable chore. One approach is to list individual elements on index cards with a headline phrase—one to a card. Secondary facts relating to the main elements also may be jotted down on the cards. After all conceivable elements have been listed, the cards may be arranged and rearranged until a satisfactory sequence is obtained. When the set of cards is compared with the amount of space available for the exhibit, it may be apparent that some elements must be discarded—or expanded. The information on the cards becomes a workable "script" from which design may proceed and preliminary labels be written. A final planning script may be in the form of a three-column outline: the first column shows the **story** as it has been worked out on the cards; the second column lists the **objects** (artifacts, maps, photos, illustrations) that will be used to tell the story; the third column lists the **structures** and/or **space** that will be needed.

The following script excerpts show how this three-column outline may be used.

EXHIBIT TITLE: MOUNTAINS, MINERALS and MEN

OBJECTIVE: Capsule history of the town of Empire, Colorado

STORY OUTLINE	OBJECTS	STRUCTURES
1. The SETTING: Rocky Mountain Continental Divide; minerals; present-day proximity to fishing and skiing areas	Relief map, 3-D letters, printed label	PANEL at entrance
2. COWLES and GRAVES sight possible way through Continental Divide barrier (later to be Berthoud Pass)	Diorama and mural size photo (30″ × 40″)	PANEL with diorama
3. "EUREKA!" — discovery of surface gold by Cowles and Freeman	Diorama	PANEL with diorama
4. Early mining methods: recovery of surface gold	Gold pan, pick, quicksilver flask, balance, nugget; single miniature figure showing use of rocker	CASE with glass front
5. North Empire in 1863	Diorama from Library of Congress photo	PANEL with diorama
6. Later mining methods: (forced by dwindling of surface materials)	Photo blow-ups taken from old map decorative border	PANEL
7. Shaft and tunnel mining and importance of burro to early operations	Burro pack saddle and shoes, miner's candle holder. Diorama showing shaft and tunnel development	CASE with diorama set in back panel. Window opening for diorama cut through back of case, diorama mounted from behind
8. Rocks and Minerals of the Empire District	Rocks and mineral specimens	CASE. Some specimens on small turntable
9. Minnesota Mines about 1940: last and greatest of the gold mining operations at Empire.	Diorama	PANEL with diorama
10. Winter sports in the early town	Diorama and pair of old wooden skates	CASE with diorama set in back of case
11. Summer activities: going to Ice Tunnel for ice	Diorama, bucket, ice tongs	CASE with diorama set in back of case
12. Summer activities: beer keg-lifting contest	Diorama	PANEL with diorama
13. Ute Indians camped in Empire valley awaiting distribution of annuities	Diorama, Indian artifacts (parfleche, pipe, pipe bag, moccasins)	CASE with diorama set in back of case
14. Use of Town Hall for various recreational pursuits	Diorama of Town Hall Ball	PANEL with diorama
15. First race track in Clear Creek County	Diorama, copies of newspaper articles	PANEL with diorama, newspaper articles mounted on front of panel
16. Building of wagon road over Berthoud Pass	Diorama: Toll Gate House	PANEL with diorama
17. One hundred years of travel over Berthoud Pass; avalanche hazards	Photos and photocopy of early newspaper	PANEL
18. Early and present-day camping, fishing and skiing	Prints (old steel engravings), photos	PANEL

NOTE: **NO** original photos and/or documents are to be put on display. COPY PRINTS of the photos and photocopies of documents will be used.

EXHIBIT TITLE: **HISTORIC NORTH AMERICAN INDIANS**

OBJECTIVE: **To counteract stereotypical ideas of "the" American Indian; to show diversity of cultures across North America, and to show relationship of cultures to environment**

STORY OUTLINE	OBJECTS	STRUCTURES
1. THERE NEVER WAS A TYPICAL AMERICAN INDIAN	3-D cut-out letters 4″ high	PANEL
2. Across North America people lived in different kinds of houses, wore different styles of clothing; were hunters, fishermen, herdsmen or farmers. HOW they lived was strongly influenced by WHERE they lived, what plants and animals were available to them. There were SEVEN CULTURE AREAS.	MAP with pictures of houses in each culture area; culture areas outlined	PANEL
3. In the ARCTIC, Eskimo people used skin boats to hunt whales, walruses, and seals. Sometimes their houses were made of driftwood, other times they were made of snow blocks. The word "igloo" means house, so there are driftwood as well as snow igloos.	**Artifacts:** fishing gear, tools, toys, clothing. **Photos:** hunters in skin boats; driftwood houses **Drawings:** how a snow igloo is built.	Exhibit CASE
4. Abundant life in the sea and the development of food preservation techniques enabled PEOPLE of the NORTHWEST COAST to establish permanent villages and to develop a highly complex social organization.	Nootka dugout canoe **Artifacts:** wooden boxes, fishing equipment, wood carving tools, button blankets, Chilkat blanket, masks, rattles, "coppers".	PLATFORM 18″ high, 4′ deep, 25′ long Exhibit CASE for "everyday" artifacts Exhibit CASE for ceremonial artifacts
5. In the CALIFORNIA-INTERMOUNTAIN area the climate was mild. Acorns from oak trees were the staple diet. Houses often were made of thatch. Beautiful and intricate baskets were made; some were decorated with bright feathers.	Model of village with thatch huts **Artifacts:** grinding stones, tools, baskets, abalone jewelry	PLATFORM 30″ high, 3′ square with plexiglas cover Exhibit CASE
6. Many people in the SOUTHWEST were farmers, growing corn, beans and squash. The farmers lived in apartment houses made of stone or adobe. They made pottery and had complex ceremonies often related to the growing season. Cotton was woven to make clothing.	Model of pueblo **Artifacts:** grinding stones, digging stick, pottery, clothing, Kachina dolls, masks	PLATFORM 30″ high, 3′ square with plexiglas cover Exhibit CASE
Other people were herdsmen. The land was poor and families, living in houses made of logs or old railroad ties, were isolated. Life revolved around the care of sheep. The women wove lovely blankets and rugs from the wool of the sheep. Many of the men were skilled silversmiths. Sandpaintings were made as part of healing ceremonies.	Model of typical hogan; loom set up outside with miniature figure of woman at loom **Artifacts:** rugs and blankets; silver and turquoise jewelry **Photos:** Loom set-up, rug being woven, Silversmith at work, sandpainting being created inside hogan	PLATFORM 30″ high, 3′ square with plexiglas cover Rugs hung floating out from wall; photos on wall next to rugs or with labels on railing in front of rugs Exhibit CASE
7. People of the PLAINS obtained horses from the Spanish settlements in the 1800s and became nomadic hunters. Living in skin tents (tipis), they moved camp often to follow the herds of bison. Often they used glass beads obtained from European traders to decorate skin clothing that was used for special occasions.	Model of camp with tipis in circle **Artifacts:** skin clothing — plain (everyday), decorated for special occasions. Hide-working tools, hide bags, horse equipment, feather headdress	PLATFORM 30″ high, 3′ square with plexiglas cover Exhibit CASE

NOTE: Rest of outline covers the people of the NORTHEASTERN WOODLANDS and of the SOUTHEAST.

In preparing the exhibit script the planner must remember the museum visitor has physical limitations. If a visitor's feet ache or if her back hurts, she will leave an exhibit in the middle of the room, and confusion created by a mass assault on her senses will send her forth without comprehending the exhibit's content.

Display also has its limitations. It can impress a viewer and help her to remember general conclusions. Rarely can it convey complicated and extensive information. These facts should be left to printed leaflets or to guides.

THE OBJECTS

While the story is being worked out in an exhibit script, the materials with which it will be interpreted are gathered together. Continuing to recognize the limitations of display, the planner must resist the temptation to put a study or storage collection on view, for some observers have noted that *most people spend no more than from thirty to forty-five seconds viewing a single display.* In this brief time, the visitor is expected to see all objects and retain all information about them. She cannot do this if she is overwhelmed with material and deluged with labels. Materials must be selected for the purpose of best illustrating the idea being presented.

A list of actual specimens on hand should be made and objects requiring it should be cleaned, repaired and restored to make them ready for exhibition. A list should be made of those things which must be obtained elsewhere by purchase, exchange or loan. If there is a gap of visual materials, it should be decided if drawings, photographs, or replicas will serve, and the preparation of these items should be scheduled.

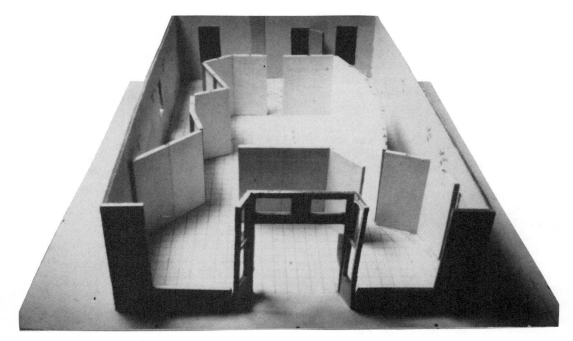

Preliminary model
Scale: ½ inch = 1

Red Men Hall Museum, Empire Colorado
Panels of file-folder cardboard reinforced with balsa wood frames.

22

SPACE: Making and Using a Scale Model

Both the extent of the story and the amount of material used will be governed by the space made available for the exhibit. At this point in planning, the use of a scale model is a great time saver. It is easier and less expensive to make changes on the scale model than in the actual exhibit hall. The model serves the further function of providing an excellent visual aid from which photographs for publicity and for grant applications can be made. Potential donors can *see* what they are being asked to fund. The model need not be elaborate.

Use a piece of ¼ inch plyboard, Upson board, or heavy corrugated cardboard for a base. Scale panels can be made from light weight cardboard such as that in file folders or index cards reinforced where needed with balsa wood strips glued to the cardboard with Elmer's glue. Heavier cardboard, such as pebble board or mat board (available at art stores) can also be used and often will not require the balsa wood reinforcing. Use straight pins to hold pieces together until the glue dries.

SOME OF THE TOOLS USED IN MAKING SCALE MODELS

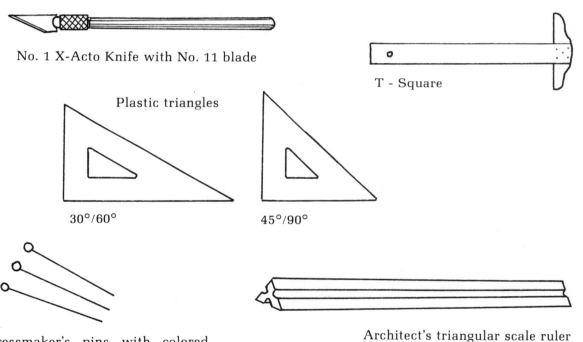

No. 1 X-Acto Knife with No. 11 blade

T - Square

Plastic triangles

30°/60° 45°/90°

Dressmaker's pins with colored rounded heads (easier on fingers than standard head)

Architect's triangular scale ruler

A list of tools for making scale models would include: A No. 1 X-Acto knife with a No. 11 blade, a small T-square, plastic triangles, a metal-edged ruler (to be used as a guide when cutting the cardboard), and an architect's triangular scale ruler. Be sure the triangular ruler is one divided for architects (in fractions) and not one divided for engineers. It should be possible to purchase all of these tools from an art supply store, the art department of an office supply store or from a hobby shop.

DEVELOPING A SCALE MODEL

Lay out floor plan graph on base

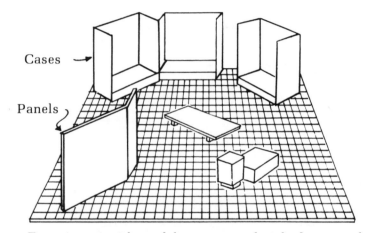

Cases

Panels

Experiment with model cases, panels, platforms and pedestals

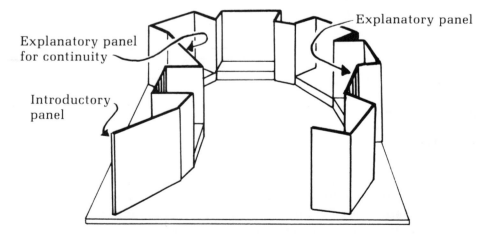

Explanatory panel

Explanatory panel
for continuity

Introductory
panel

FINISHED FLOOR PLAN

To make a scale model of a gallery, use the one-half inch to one-foot scale and draw a graph of squares on the base piece, then draw in the floor plan of the existing room which is to be used. Be sure to indicate the presence of windows and doors and the direction in which doors open. It is also a good idea to draw in the location of electric outlets.

Make individual models of the proposed panels and cases, floor platforms, pedestals, and any other exhibit structures which will be used. These individual models need not be detailed—just something to give the correct idea of bulk and floor space requirements. Cut a scale figure using lightweight cardboard; glue a small scrap of cardboard to the base so the figure will stand. Use of this figure will help to visualize the cases and panels in relation to the visitor's size.

One-half inch scale

By moving these model exhibit structures around the base and correlating their placement with the written outline, the floor plan will develop. Using a scale model helps in designing a traffic pattern which will be easy for visitors to follow and gives the specialist (historian or scientist) a concrete idea as to how the display will be handled. Use of a model permits both the specialist and designer to correct any aspect of the presentation that seems wrong and gives everyone concerned a realistic approach to determining costs for, on the scale model, it can be seen where existing cases and panels may be used and where new structures must be made.

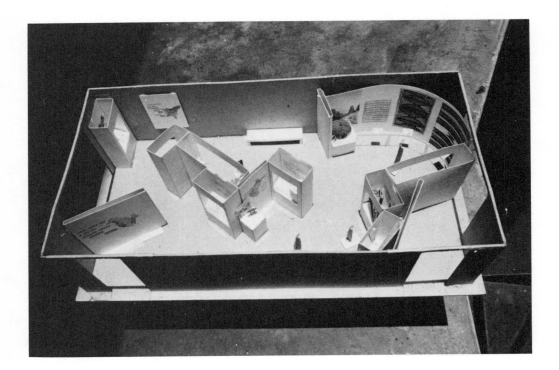

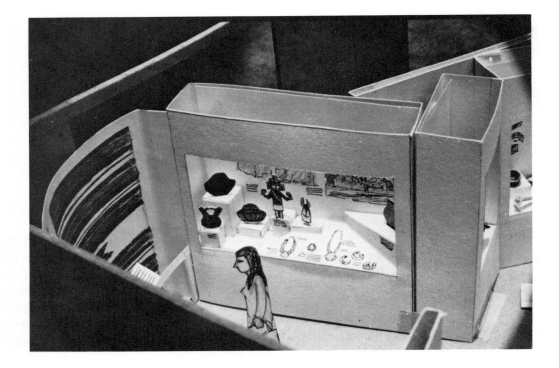

Scale Model developed from exhibit outline shown on pages 20 and 21.

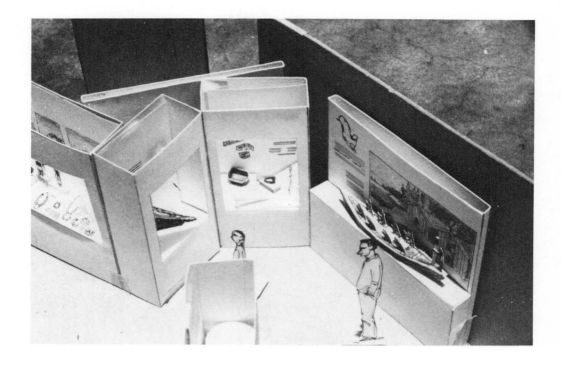

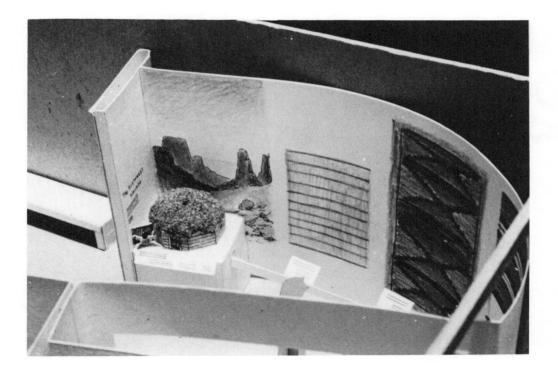

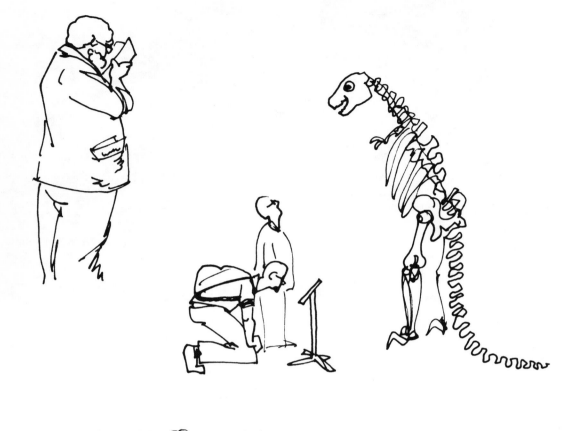

THE MUSEUM "AUDIENCE"

The museum audience is neither specialized nor captive but consists of such extremes as school children and scholars, Sunday strollers and tourists. Even if the designer considers every behavior rule she has ever learned, some atypical visitors will confound traffic patterns, ignoring in their own observation of the displays every attempt by the designer to direct and guide their attention.

The designer's basic planning should include a recognition of some physical facts about people. If visitors have headaches, bloodshot eyes, tired backs, sagging arches and burning feet after they have seen the museum's exhibits, the designer has forgotten to consider how people are built. By far the most common error in exhibit design is the placement of objects and label texts in positions far too high or far too low for comfortable viewing.

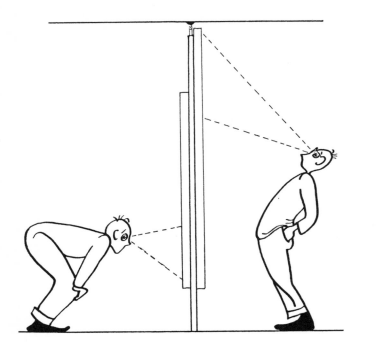

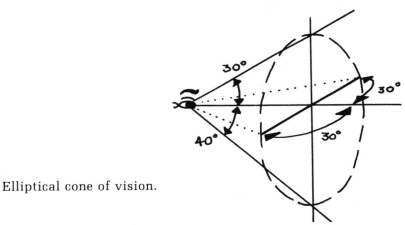

Elliptical cone of vision.

The man on the left is having trouble because detailed things more than three feet below his eye level are difficult to see. The man on the right is having equal difficulty with a label that is more than one foot above his eye level. If either man is wearing bifocals he probably will abandon any effort to see the exhibit rather than acquire an uncomfortable crick in his neck.

With little eye movement, people usually see and recognize with ease things that are within an approximately elliptical cone of vision (illustrated here) with the apex of the cone at eye-level height.

Limits of *comfortable* head movements.

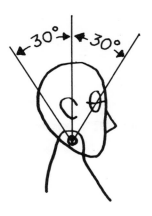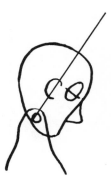

Up and **Down**

Comfortable head movements

from **Side** to **Side**

Arranging objects and labels beyond these visual and physical limitations will place a strain on seldom used muscles and produce a severe case of museum fatigue.

Average body and eye-level heights for American women, men and six-year-old children. These are **important to consider** when planning exhibits!

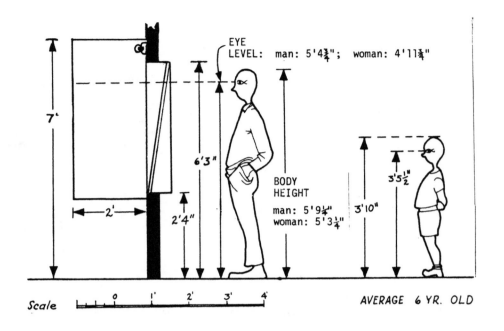

EYE LEVEL: man: 5'4¾"; woman: 4'11¾"

BODY HEIGHT
man: 5'9¼"
woman: 5'3¼"

7'

2'

6'3"

2'4"

3'10"

3'5½"

Scale 0 1' 2' 3' 4'

AVERAGE 6 YR. OLD

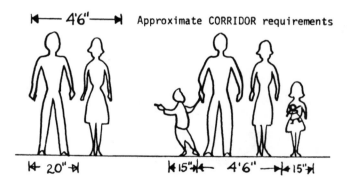

← 4'6" → Approximate CORRIDOR requirements

← 20" → ← 15" →← 4'6" →← 15" →

PLATFORM and PEDESTAL spacing

7' minimum

7'

Walks terminating at doors should have a 5' x 5' level platform extending *at least* 1'6" beyond the strike jamb on the pull side of the door. Where possible, a wider space is much preferred.

The 1'6" allowance to the side of the door is to allow persons in wheelchairs to move to the side of the door and open the door without backing in the chair.

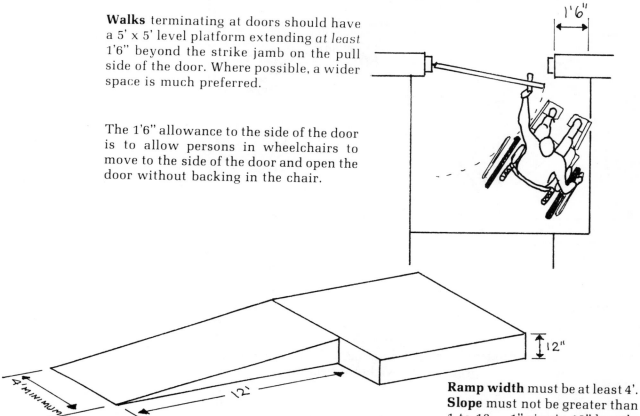

Ramp width must be at least 4'.
Slope must not be greater than 1 to 12. . .1" rise in 12" length.

An adult wheelchair is about 27" wide.
Doorways should be at least 32" wide to allow clearance for hands.
Corridors or **halls** require 60" minimum clearance.

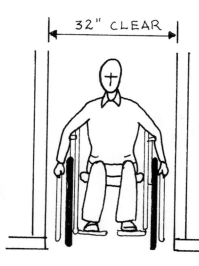

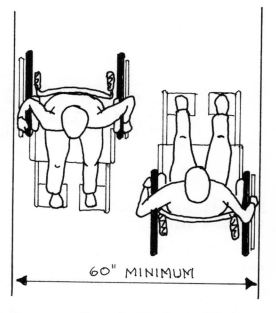

Information and drawings are taken from: *An Illustrated Handbook of the Handicapped Section of the North Carolina State Building Code*, by Ronald L. Mace and Betsy Laslett, North Carolina Dept. of Insurance, 1977.

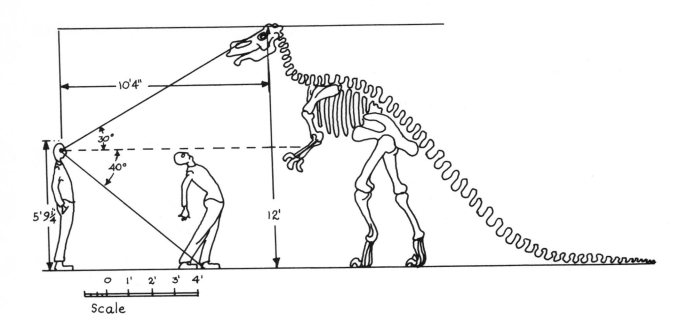

Some quite large objects, such as murals, heroic statues, Greek friezes, Egyptian tomb paintings, totem poles or dinosaurs, will inevitably soar above the viewing limits shown previously and in this event, the visitor must be permitted space to back far enough away from the object to comprehend it without becoming a case for an orthopedic specialist.

One of the main things to remember about the visitor is the short time span she will devote to each exhibit. Therefore, plan displays to emphasize those *main, basic, elemental* facts you wish her to carry away.

It is equally important to remember that museum fatigue is an ever-present problem. Places for the visitor to sit down to rest *must be planned* as a part of the regular traffic flow pattern.

EXHIBIT STRUCTURES: Panels, platforms, pedestals, cases and Plexiglas covers

Virtually *any* exhibit can be assembled using combinations of panels, platforms, pedestals, cases and Plexiglas covers. Over the past few years I have recommended increasingly that these modular units be used rather than permanent built-in construction—even for "permanent" exhibits. ("Permanent" is in quotation marks because hardly anything *is.*) The modular units permit great flexibility both in setting up the original exhibition and in making minor or even major

changes when these are necessary. With a combination of modular units, an attractive variety of planes can be created and an easy-flowing traffic pattern can be established. Moreover, the units are easy and relatively inexpensive to build.

Working from the exhibit script, a list should be made of the required units then storage areas should be checked to determine how many pieces are already on hand and how many extra will need to be built. Some construction methods are shown in Part II of this book. Other ideas may be gained by reading home "how-to-do-it" books such as those published by *Sunset Magazine*, e.g. *How to Make Bookshelves & Cabinets, Sunset Ideas for Storage*, etc. (Lane Publishing Co., Menlo Park, California 94025.)

Acquiring a knowledge of construction materials will begin with "field" trips to lumber yards, mill shops, wrecking yards, sheet metal yards, hardware and building supply stores. Wrecking yards are included for in these one may find just the weathered wood, leaded windows, elaborate mantlepieces, slabs of marble, intricate brass hinges or other items that will just exactly set off a portion of a gallery. Wrecking yards are also an excellent source for well-aged framing lumber. Sheet metal yards often will have scraps of new materials—aluminum extrusions, tubing, and sheet stock—at reduced prices. Surplus stores (those dealing in tools, radio parts, aircraft surplus, nuts and bolts) may have just the gadget that can be adapted to put motion or a changing light effect into an exhibit. Businesses supplying display materials for department stores often will have accessories that are both useful and reasonably priced. Do not be startled, at the end of August, to enter one of the stores and be surrounded by a Christmas atmosphere. Seasonal items are stocked three and four months in advance.

One of the best ways to build up an information file about products is to write directly to the manufacturers. The American Association of Museums includes a list of materials and suppliers in a section of its annual directory. This is a most useful reference—updated each year when the directory comes out.

A thorough knowledge of design factors comes through training and experience, but the amateur can gain much by a continual awareness of design elements used in every visual medium. The alert museum preparator will find herself looking at highway billboards, magazine editorial and advertising layouts, television titles, department store displays, travel agency windows, bank and financial company exhibits, trade fairs, liquor-store and bar countertop displays, and any number of other places where good design may be apparent, and thinking, "how can I adapt that to the museum?"

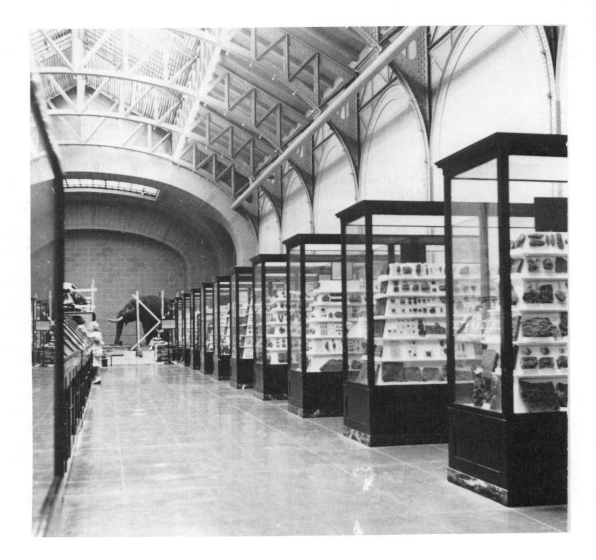

Gallery Design

Early museums which put study collections on display in the "visible storage" style previously discussed, often arranged the materials in broad categories and the display cases were placed in the galleries following a plan that is most reminiscent of book shelves in a library. This monotonous row-on-row layout survives to the present and frequently confronts museum visitors today.

In other museums, cases line the walls and the floor area is cluttered with unrelated left-over table cases and objects too large to be placed in the wall cases. "Confusion" best describes the "inspiration" for a room of this design.

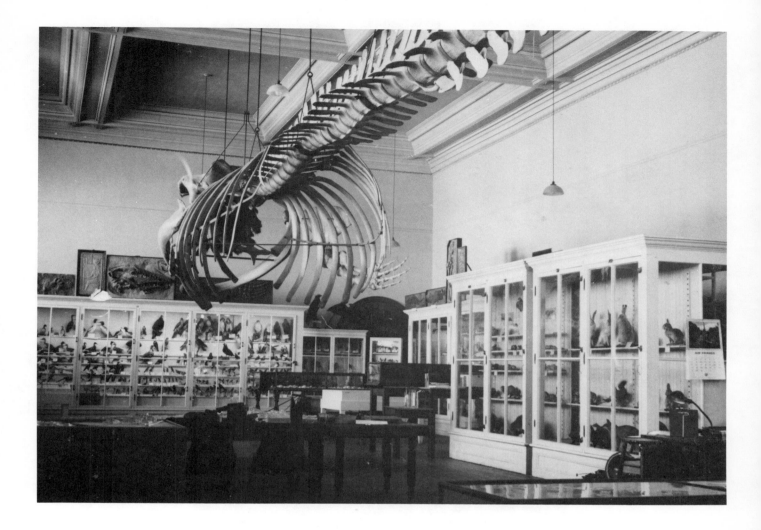

On entering the building, the museum visitor is disoriented. The monotony and/or clutter of these arrangements will do little to help one decide what to see first and what path to follow. Indeed, the first impression of the room may create such visual fatigue that the visitor may decide to by-pass the exhibits altogether. If you have inherited a room arrangement similar to these, and the cases cannot be moved without being damaged, dismantle at least every other case and remove it to create a more free circulation for visitors and to provide areas for informational panels. However, with the helpful advice of your local moving companies and the aid of jacks and dollies, it is surprising how many seemingly permanent installations can be rearranged. The re-installation should proceed as finances and time become available.

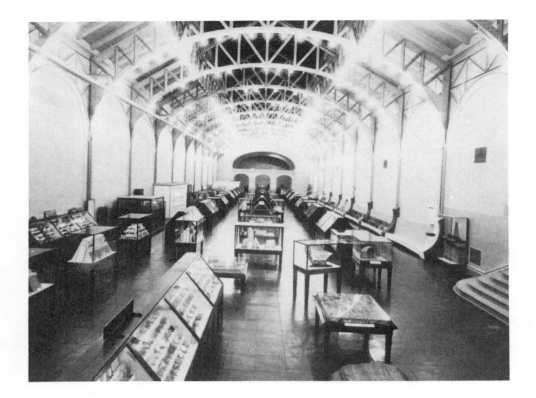

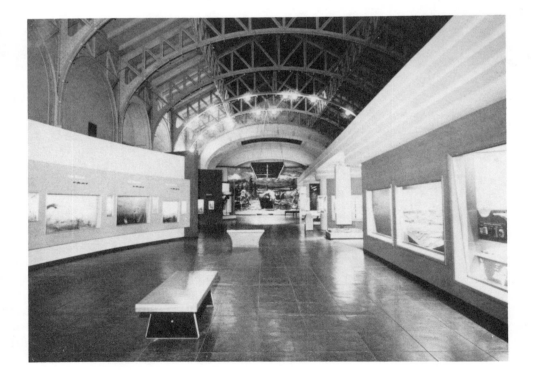

Both photos this page courtesy of the New York State Museum, Albany, New York.

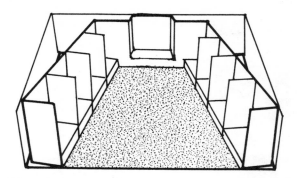

If nothing more is done than to pull some cases from side walls, tapering their lines to a far wall so that the boxiness of the room disappears, the gallery will become more inviting. It is possible that moving the cases around will create space for storage or work areas between them and the walls.

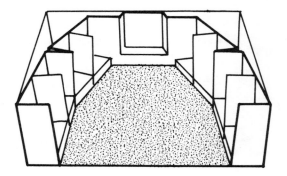

The flow of visitors is like the flow of water in a stream. If the cases are arranged with gently curving lines to take advantage of this pattern of movement, visitors will find the room more attractive and can progress easily with the line of cases.

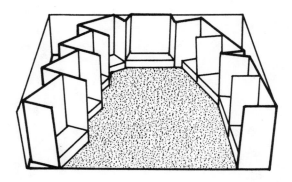

Often some of the cases can be arranged in a staggered pattern which produces a certain mystery and a desire on the part of the visitor to peek around corners to see what is next.

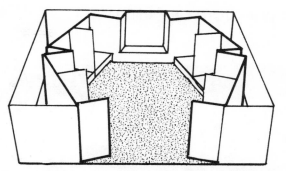

It is not always necessary to have a wide opening into a hall. When cases are arranged to narrow the entrance a bit so that the hall inside then opens out, a certain amount of interest is created.

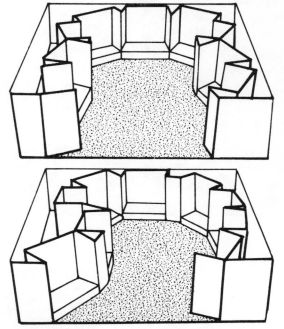

Working with the exhibit script reveals logical divisions in the story and these help to determine alcove arrangements of the cases. The alcoves thus separate, by actual physical divisions, the various parts of the story.

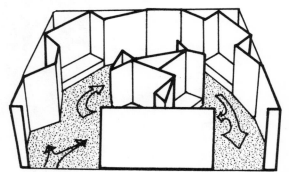

If the room is large enough some cases may be placed to form an island creating a more definite path in the room interior.

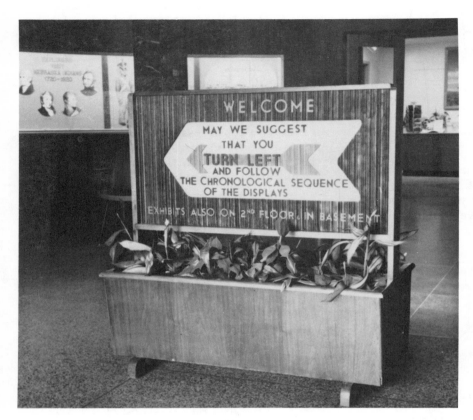

A capsule history of the state presented immediately inside the building entrance.

Attractive, well-designed and well-executed "single-topic" displays permit the visitor with little time to gain a token idea of Nebraska's story.

Nebraska State Historical Museum, Lincoln, Nebraska

Visitors instinctively grasp rail installed just below window area instead of leaning hands on glass.

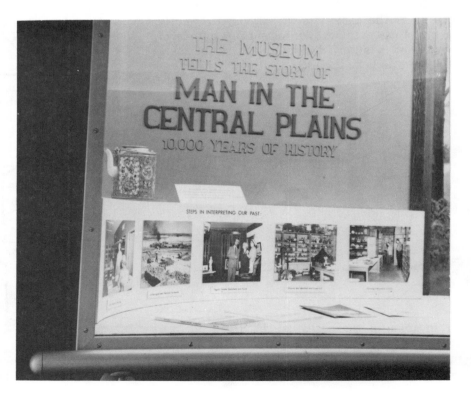

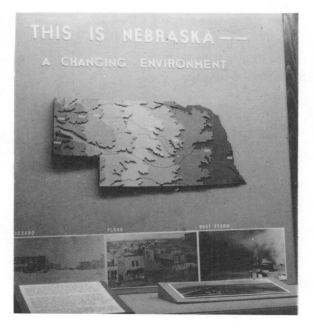

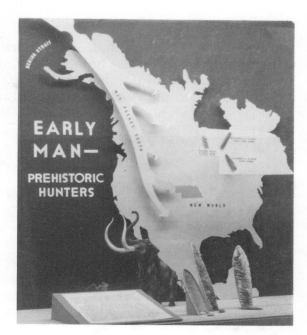

Exhibit case is a continuous area divided by design
elements rather than by physical barriers.

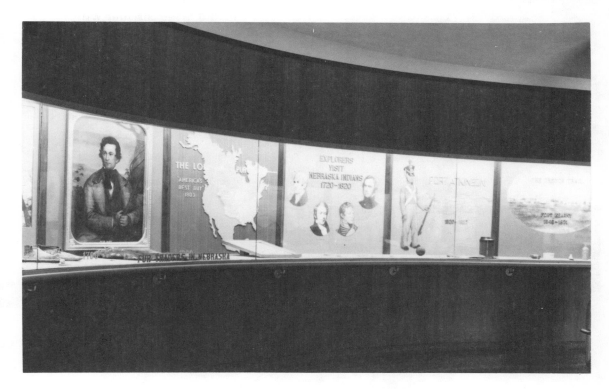

Maps, paintings, and photographic enlargements
are among graphic devices used.

Corridors

The physical proportions of corridors present problems that are difficult but not impossible to solve. It is important to check with local building authorities for safe and required minimum corridor widths before starting to plan any hallway exhibits.

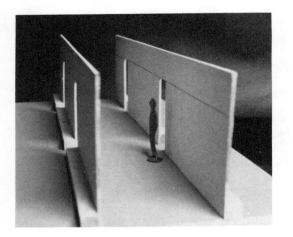

Models of some suggested treatments of corridors.

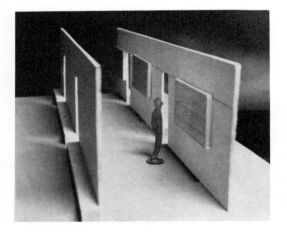

Typical 8' wide corridor with 10' high ceiling; picture molding at 7' level.

Usual horizontal panel installation emphasizes length of hall, creates monotony.

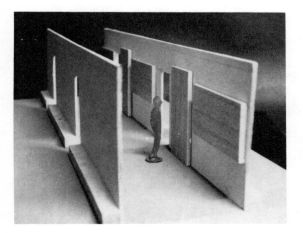

Addition of vertical panels helps to break up horizontal line.

Variations on the **vertical panel**

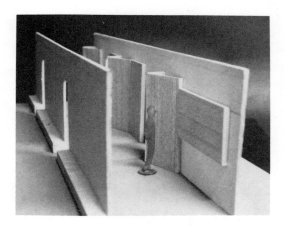

Whenever a surface to be seen is parallel to the visitor's path, the visual material often will be overlooked.

Placing the panel on a slight angle with the wall helps to interrupt the visual length of the corridor. (4' wide panel extends 2' on one side.)

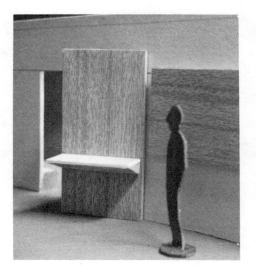
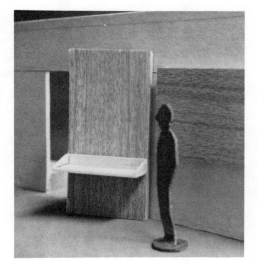

Reversible shelf.

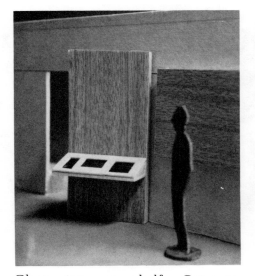

Glass top on shelf. Cut-outs emphasize small objects.

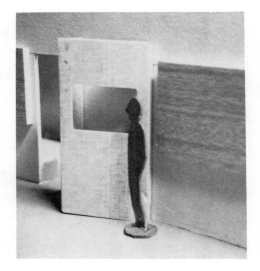

Shallow case.

Both cases below extend 30" into hall. Outer ends are supported by spring-loaded poles.

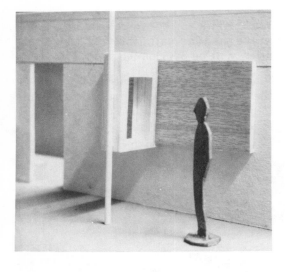

"See through" specimen case 12" wide.

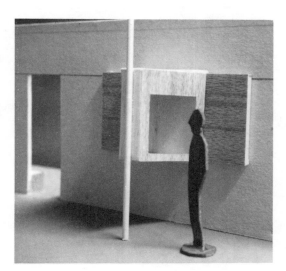

Shallow triangular case 48" wide on panel tapering to 12" wide.

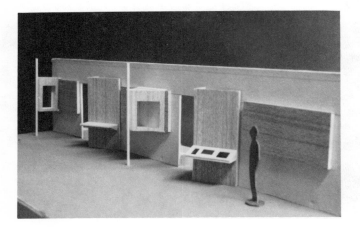

Corridor arrangement with variation of panels and accessories.

Actual Corridor Installations

Architecture and **materials** of **design**

Joslyn Art Museum
Omaha, Nebraska

Note use of door to help break horizontal line and to reinforce architectural theme.

All measurements are approximate.

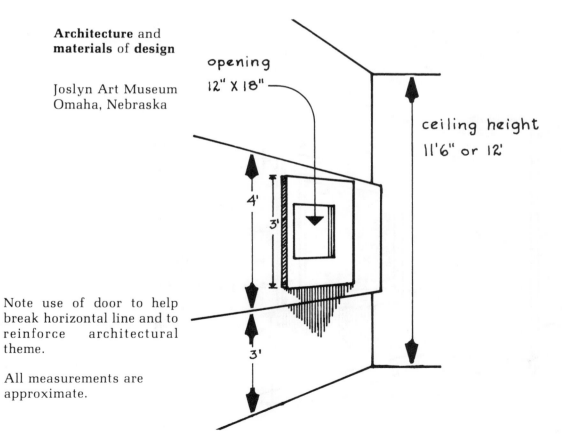

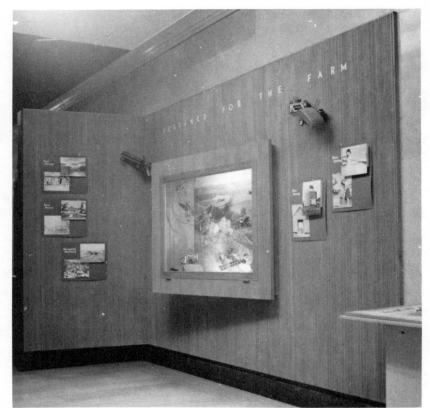

Designed for the **farm**.

Joslyn Art Museum
Omaha, Nebraska

Angled wall case and right-angle panel isolate and unify material.

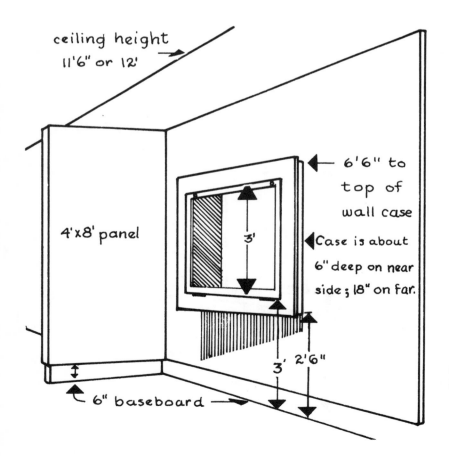

ceiling height
11'6" or 12'

4'x8' panel

6'6" to
top of
wall case

Case is about
6" deep on near
side; 18" on far.

3'

6" baseboard

3' 2'6"

All measurements are
approximate.

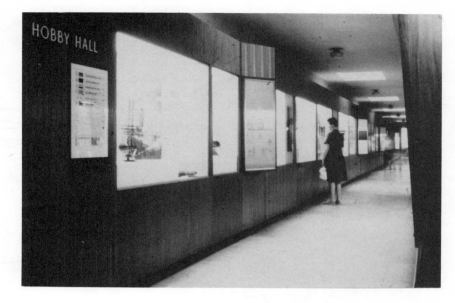

Carnegie Museum
Pittsburg, Pennsylvania

Hobby Hall

Shallow wall cases with triangular space-dividers provide an area for changing exhibits.

Lighting Corridor Exhibits

A run of duplex outlets on thin-walled conduit may be installed high along the wall to provide plug-ins for lights in shallow case exhibits. Fluorescent lights will not be as hot as incandescent.

Lighting may be adapted for *panels* by either of the two following methods:

1. Remove glass shade and light bulb from existing corridor light; replace with screw-in swivel socket.

 Screw reflector flood or spot light into swivel socket.

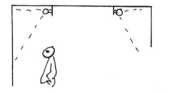

2. Wide corridors may be lighted by fluorescent lights hidden behind a light baffle.

47

Lighting a remodeled case.

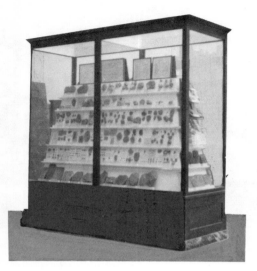

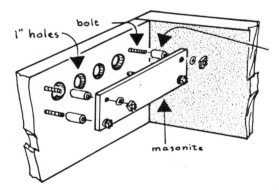

Simple open-top light box built of 1"x10" boards with two 1"x4" cross supports and a 4' flourescent fixture. Fixture is held 1½" from wood supports by pipe-nipple spacers (see Construction Section). Light cord may be held to underside of wood cross supports and dropped down behind remodeled case.

A **CLOSED light box** should be built so that hot air from the lights can escape.

Baffle for closed light box: Baffle of ¼" masonite attached with 2½" long ¼" flat-head stove bolts, washers and nuts. Lengths of ⅜" inside diameter *garden hose* cut 1" long make spacers to hold baffle from side of light box. Hot air can escape but light is controlled.

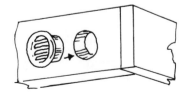

Alternate method: Drill hole to accept "push in" vent.

Exhibit Cases

Often one is burdened with old cases equipped with glass doors, glass sides, and perhaps even a glass top. These glass surfaces pick up reflections from all over the room and from one another, making objects almost impossible to see. The remodeled case shown can be done in the following way.

Remove the glass doors and sides. Leave the glass top; the glass will help to filter ultraviolet rays of fluorescent lights. Build a light box to rest on top of the case. This will hold one or two four-foot fluorescent light fixtures. If the light is too harsh in the case, smear the glass top with some powdered cleanser such as Comet. The dried cleanser will help to diffuse the light. A weak spotlight effect can be achieved by wiping the cleanser off in a small circular area, leaving a clear glass "window" surrounded by translucent cleanser-covered glass. A stronger spotlighting can be created by spray painting the top of the glass with a thin spray of white from a spray can of paint. A clear glass "window" should be covered with masking tape *before* using the spray and, when the paint is completely dry, the masking tape is pulled off.

Do not fasten the light box to the case; let it rest on top so that replacing lights will be easy. A strip of foam rubber weatherstripping glued around the bottom edge will help to prevent light from spilling out. The top of the box may be left open to contribute to the general room light, or may be closed to direct more light into the case interior. If closed, the box is painted with white on the interior to help reflect additional light into the case. A closed box *must* have some way of letting out the heat from the lights. Holes may be drilled through the ends of the box and a light baffle built on the inside. Or holes may be drilled to accept "push-in" vents.

Replace the glass of the back and sides of the case with quarter-inch or three-eighths-inch plyboard. If the glass is of good quality, free of ripples and many scratches, save it to be used on smaller cases that may be designed later. Remember that old glass may be brittle and can be very dangerous. **Be careful!** If it is not usable in the museum, try to sell it to a local salvage company.

Make a frame for the front of one-inch by ten-inch pine boards, fitting so it will just slide in the case. Push it in about four to six inches and fasten it securely. Screw strips of quarter-round molding to the frame for back stops for the glass. *Set the strips so that the glass will be at the maximum slant possible with the ten-inch wide lumber. The slant will help to minimize reflections.* Cut duplicate quarter-round for the front side of the glass. Set up the exhibit in the case, put in the glass, and screw the front set of molding strips to the frame.

In this remodeled case, it will be necessary to remove the glass to change exhibits. Making the back removable is not much help; it is very difficult to install an exhibit from the back.

The larger case shown represents a different problem because of its size. The solution is similar but varies slightly.

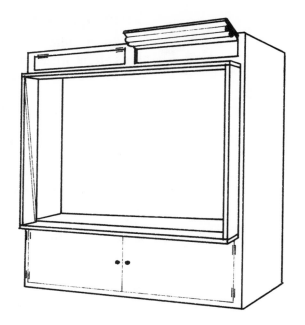

Remove the glass from the sides. Remove the front doors and take out all shelving and shelf supports. Knock out the old flooring and build a new floor at least twenty-four inches from the floor of the room. If storage space is desired, cabinets may be built in under the floor of the case. Build a frame for the glass similar to that shown with the previous case, but hold the frame at least fourteen inches from the top. Across the top, directly above the frame, make two hinged access panels to which fluorescent light fixtures will be attached. Opening these panels makes it possible to change burned-out lights without opening the case. Cover the visually busy tongue-and-groove boards in the back with a solid sheet of half-inch Cellotex or similar material. Replacing the glass sides with three-eighths-inch plyboard makes these side panels removable and gives access to the case without having to remove the glass.

Remodeling of this typical old-style floor case is very easy and can be done without having to disassemble anything but the interior.

50

(From a demonstration at the Adirondack Museum, Blue Mountain Lake, New York. Remodeling and case installation by H.J. Swinney, Director and George Bowditch, Exhibit Designer.) Light box similar to that on page 48.

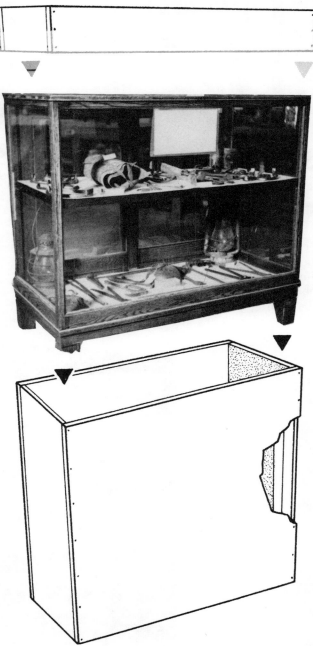

Base made of ½" plyboard reinforced at the corners with 2" x 2" lumber.

Protruding edge of case rests on top of plyboard base. Weight holds pieces together. Light box rests on top of case.

Photo by George Bowditch.

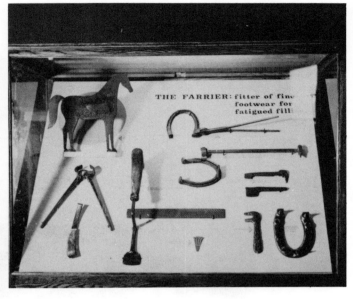

Sliding glass doors in back of case were lifted out and shelf was removed. A triangular box with selected tools attached to the front sloping panel was slid into the exhibit case and the glass doors were replaced. Excess materials were stored behind the sloping panel. Had this been a permanent remodeling job rather than a demonstration the sliding glass doors might have been painted or replaced with masonite.

Remodeling the case shown proceeds as follows. Glass on one long side is replaced by half-inch plyboard for a base, and the whole case is tipped up on that side. The case is set on a new stand at least forty inches high, and a light box is made to rest on top. The two short sides of glass are replaced with plyboard and a frame is made for the glass. The sides of the frame are cut on the slant the glass will follow. On this smaller case, the tapered cut keeps the shadow-box frame from appearing top-heavy. The contents of a case of the proportions shown would probably be viewed from a short distance, so it would not be objectionable to use two pieces of glass for the front, joining them with a strip of metal or wood molding.

An alternate method shows the case remaining a floor display rather than being converted into a wall case. The only changes are to raise the case so that the base is at least forty inches high (again creating storage space under the display area), and to make two light troughs, each trough to hold two twenty-four-inch fluorescent fixtures, which are fastened inside the glass at the top front and back edges of the case. The light cord extending from the base of the case may be placed on the floor and covered with a protective plastic molding. If the material to be shown is such to be of interest to children, an eight-inch high, eighteen-inch wide step (riser) may be placed on each side.

When all the cases have been remodeled, they may be distributed around a hall or gallery and a series of panels built on two-by-four framing installed between them to begin a continuous gallery wall.

DETAIL "A"

The two-by-four framing is covered with masonite, plyboard, plasterboard, Upson board or similar material, the joints and nail-holes are spackled and the wall is painted.

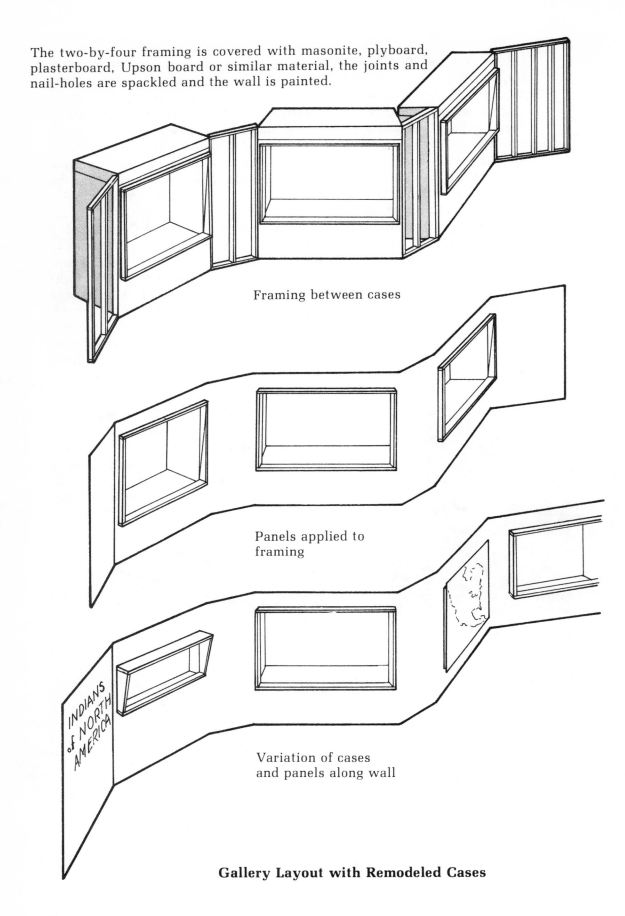

Framing between cases

Panels applied to framing

Variation of cases and panels along wall

Gallery Layout with Remodeled Cases

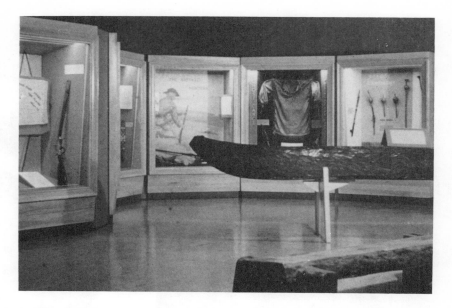

Individual cases with narrow connecting panels form an alcove in the Nebraska State Historical Museum.

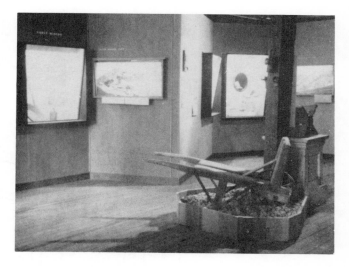

Panel wall with cases; Red Men Hall Museum, Empire, Colorado.

If the wall of the alcove is varied by the use of informational panels between some cases and the use of different size cases, such as those previously described, the room takes on more visual interest.

EXHIBIT CASES—New construction

Simplified construction and the use of plyboard helps to hold down construction costs of new cases similar to those shown here.

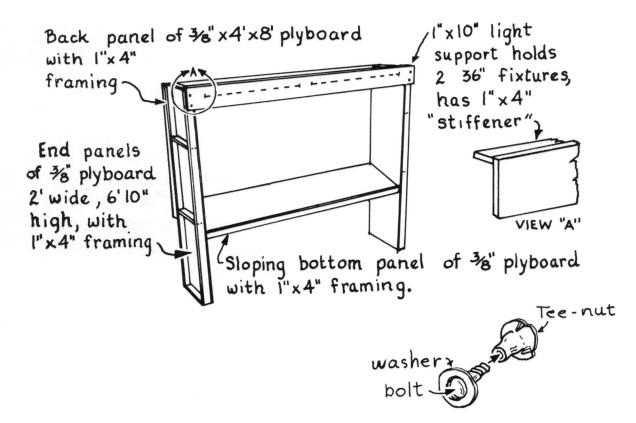

Back panel of ⅜"x4'x8' plyboard with 1"x4" framing

1"x10" light support holds 2 36" fixtures, has 1"x4" "stiffener"

End panels of ⅜" plyboard 2' wide, 6'10" high, with 1"x4" framing

Sloping bottom panel of ⅜" plyboard with 1"x4" framing.

VIEW "A"

Tee-nut
washer
bolt

Panels are assembled with bolds and Tee-nuts.

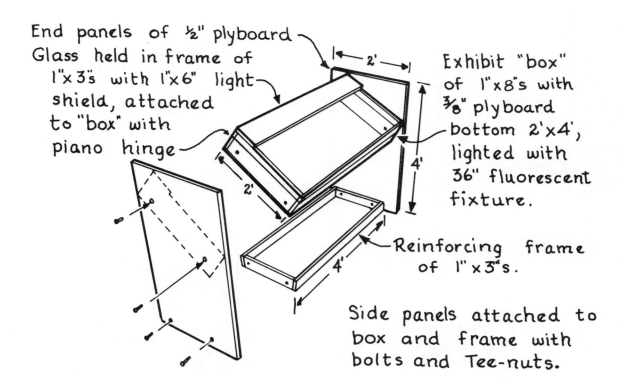

End panels of ½" plyboard
Glass held in frame of
1"x3"s with 1"x6" light
shield, attached
to "box" with
piano hinge

2'

2'

Exhibit "box"
of 1"x8"s with
⅜" plyboard
bottom 2'x4',
lighted with
36" fluorescent
fixture.

4'

Reinforcing frame
of 1"x3"s.

4'

Side panels attached to
box and frame with
bolts and Tee-nuts.

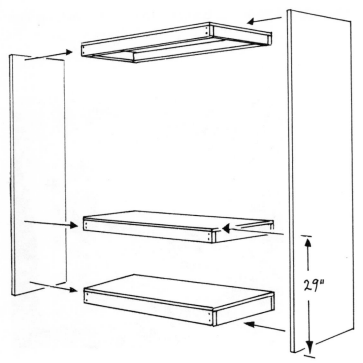

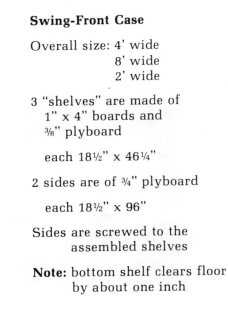

Swing-Front Case

Overall size: 4' wide
8' wide
2' wide

3 "shelves" are made of
1" x 4" boards and
⅜" plyboard

each 18½" x 46¼"

2 sides are of ¾" plyboard

each 18½" x 96"

Sides are screwed to the
assembled shelves

Note: bottom shelf clears floor
by about one inch

Detailed drawings are on pages 38 and 39 of *Exhibits for the Small Museum*,
published by the American Association for State and Local History, 1976.

Back is full sheet 4' x 8' of half-inch
plyboard screwed to shelf framing;
glued and nailed (with finishing nails)
to sides.

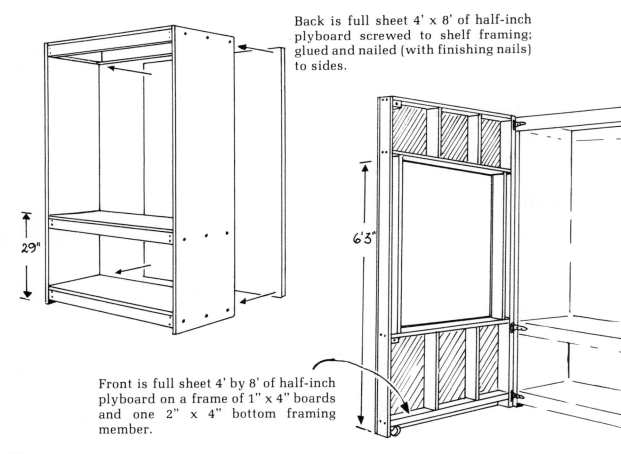

Front is full sheet 4' by 8' of half-inch
plyboard on a frame of 1" x 4" boards
and one 2" x 4" bottom framing
member.

Free-standing Exhibit Case, 6 feet wide

(See page 73 in *Exhibits for the Small Museum* for construction details of dolly—used to carry weight of glass when case is opened.)

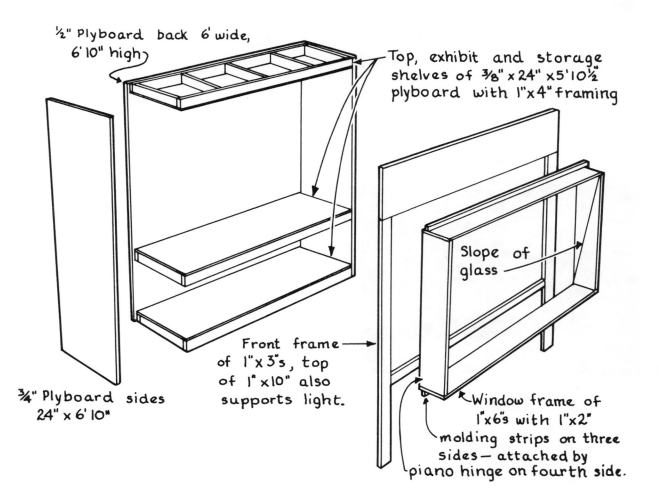

½" Plyboard back 6' wide, 6'10" high

Top, exhibit and storage shelves of ⅜" x 24" x 5'10½" plyboard with 1"x4" framing

Slope of glass

Front frame of 1"x 3"s, top of 1" x10" also supports light.

¾" Plyboard sides 24" x 6'10"

Window frame of 1"x6"s with 1"x2" molding strips on three sides — attached by piano hinge on fourth side.

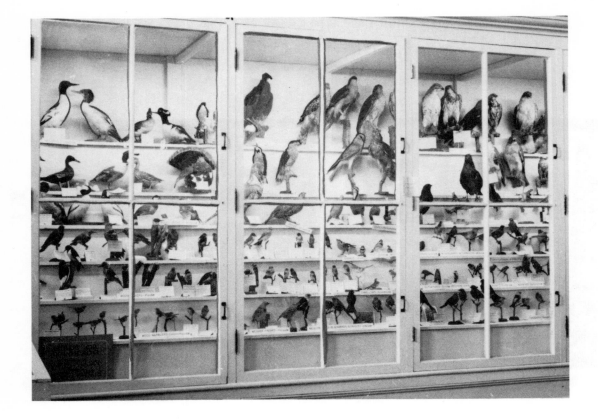

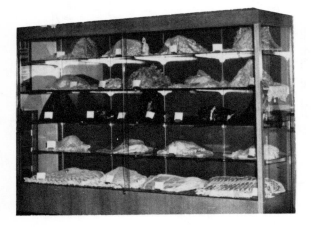

Birds or linens—
this is visual monotony.

CASE EXHIBITS—Designing the setting

A case arranged with shelf after shelf of the same kind of object is just as monotonous and boring as the hall with row after row of cases. How the felony is compounded in a gallery where the row on row of cases are filled with shelf after shelf on which are displayed similar items, one after the other!

Try to avoid repetition.

Do not be afraid to avoid the boxiness of a case by putting in panels and false sides that angle from one side to the back. They can be used for main labels or for object display and are made of plyboard, Cellotex, Upson board or other panel material. Do not worry about mistakes in carpentry. Use Durham's Rock Hard Water Putty or Synkaloid Spackling Paste to fill the cracks. Be sure also to putty over the nail heads.

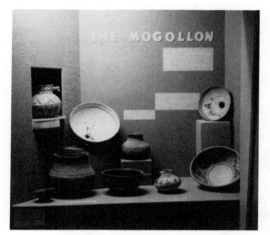

Hole cut in panel on left of case emphasizes pottery. Simple Cellotex boxes—"case furniture"—are used with the remaining materials.

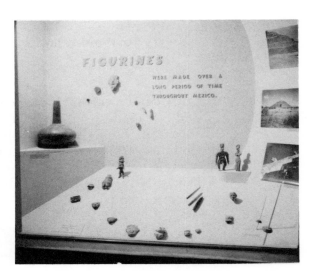

A background panel which curves from side to side or from top to bottom is made with one-eighth-inch Upson board, called "Easy-Curve," which is available from lumber companies in sheets four feet by eight feet. A local dealer who may not have Easy-Curve in stock can order it.

Panels may also slope from front to back. Use half-inch Cellotex and support it underneath with braces of one-inch by three-inch boards.

Often it is possible to combine sloping and angular panels or sloping and curved panels. Try many different arrangements. Try also not to repeat the same pattern of display within one hall.

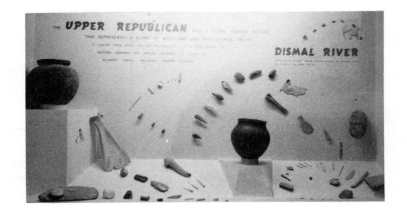

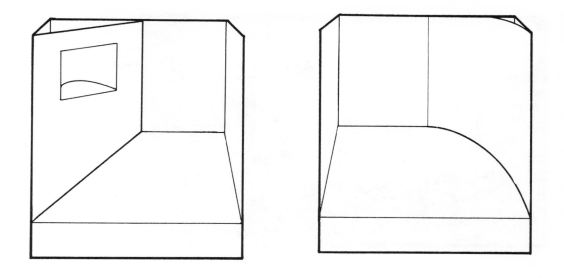

Combinations: Sloping and angular; sloping and curved.

Patterns for difficult fitting jobs may be cut from large pieces of corrugated cardboard. Cartons, such as shipping containers for mattresses, refrigerators, TV sets and other large appliances are an excellent source for large sheets of corrugated cardboard.

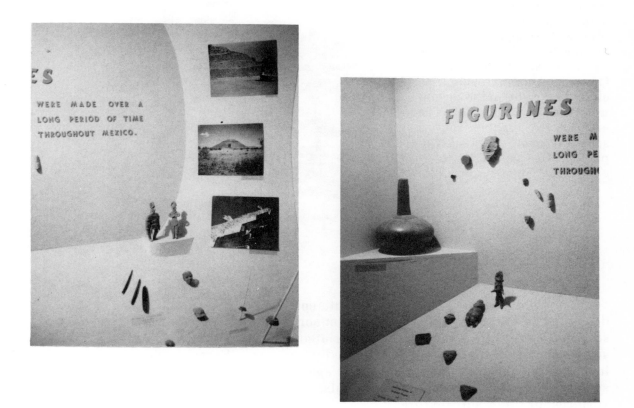

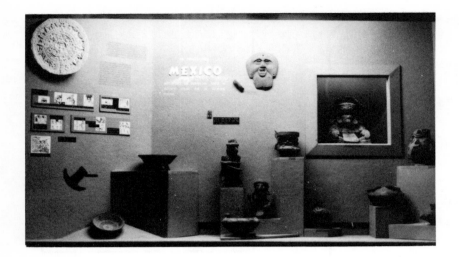

Another variation is to cut a hole through the back of the case behind which a large artifact, photograph, or painting may be fastened.

The panel on the left (**above**) which angles from the front of the case to the back, cutting across the corner, is made of plyboard to support the weight of a plaster replica of the Aztec calendar stone. The Easy-Curve background behind the effigy pot (**right**) in the cut-out is curved from side to side. The artifact is lighted by a spotlight made from a two-pound coffee can.

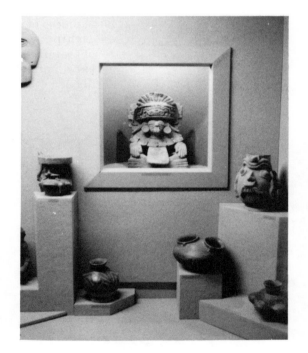

Remember to constantly use light, color, and texture in the designing of exhibits. Try a spotlight on some things. Use materials such as plastic, fabric, sandblasted or striated wood; glue sand on some surfaces; try the effect of corrugated cardboard. Exercise your imagination. Try to counter one texture against another. For the hard surface of glass, metals, and minerals, try velvet cloth, flocked surfaces, or other soft textures.

The bottom of the case may be covered with some kind of texture: *washed* sand, pigeon grit, or gravel provide an interesting surface. More to the point, the texture hides dust and dirt. If you use materials such as wood chips, driftwood, timberline wood, leaves, or other natural objects, be sure to give them a thorough treatment with Raid or some other insect killing spray *before bringing them into the building.*

CASE EXHIBITS—Designing the arrangement of objects

Before a few of the design factors involved in arranging objects are described, the problem of museum fatigue should be mentioned once more in its relation to the eye, to vision, and to comprehension. Convergence, by which our two eyes see as one, is brought about by two sets of muscles, six for each eye. Focusing is done by muscles attached to the lens. As with most muscles, fatigue will come to these eye muscles when they are held in the same position for some length of time. The muscles that, in focusing, contract or expand the lens will tire quickly if there is little or no variation in the depth of object placement within a case. The monotony and boredom of an almost constant focal depth produces a kind of hypnosis similar to that experienced when driving a long, straight stretch of road. At the same time, there should not be a clutter of too many focal planes within the case.

Comprehension as well as vision must be at a high level for one to combat the ever-potential museum fatigue. This is comprehension of the object itself—its shape, material, and size—not the understanding of the identifying label. If, in an enthusiasm for "atmosphere" and "psychological effect," case lighting is not adequate, the effort to see and to comprehend the materials being displayed cancels the attempted effectiveness of the setting. Some factors that will bring on visual and eventually full body fatigue are: monotony in color, texture and light; straining to see without adequate light; straining to see against improperly directed light (such as a spotlight in another area of the gallery, daylight coming through windows, multiple reflections of light in glass); and quantities of objects displayed with no regard for visual selectivity and flow.

Each case should have one area (an object or small group of objects) as a focal point. Then, as the traffic flow in a gallery is directed in a pattern by the design and placement of cases and panels, a visual flow within the case should pick up from the focal area of interest and be established through design factors such as emphasis (size and placement), blank space, color, line, shape, texture, and light. The use of these factors will help to accent, select, set apart, or consolidate information. A typical display problem is that of a number of objects which differ perhaps only in minor details—prehistoric pottery, mineral specimens, guns, or a series of clocks. Making the most appealing, interesting, significant, or important specimen a key attraction and using one or a combination of design factors attracts the eye to that key specimen and will lead it to the others.

Wherever possible, all materials should be shown in the same position as they were when used, helping the visitor to visualize the function.

Design Factors used in Arrangement of Objects

Emphasis through size (of case furniture) and placement;

Emphasis through isolation;

Emphasis through color (if specimens permit);

Emphasis through line, size and placement;

Emphasis through shape (by color or overlay of different material);

Emphasis through texture;

Emphasis through light, size and placement.

One approach to the problem of designing the layout is to set the objects in the case, working with stacks of books, two-pound coffee cans, boards, cigar boxes, cardboard cartons . . . anything that will give the desired height. By experimenting with the boxes and objects, considering the size and location of case labels, one arrives at a final design that attracts and focuses attention, then leads logically through the case.

CASE EXHIBITS - "Furniture"

The term "case furniture" refers to the boxes, pedestals and other structures used to support the exhibit specimens. They may be simple rectangular forms or more elaborate structures.

After the case layout has been determined (as described above), measure how high, wide, and deep the boxes for case furniture must be. Make the boxes from pieces of one-half-inch Cellotex, three-eighths-inch Upson board, quarter-inch Fomecor (for light-weight objects), or, for heavy specimens, three-eighths-inch plyboard. Pieces are fastened together with Elmer's white or carpenter's glue and tacked with finishing nails which are set just below the surface. Raw edges are filled with spackling paste which is sanded lightly when it has dried.

Ordinary water-based (latex or acrylic) house interior paints are used for painting both the case and the boxes at the same time, so that they will match. Paper for labels is also stretched and painted at this same time, creating paper the same color as the case. In most case designs, it is better that this "furniture" and the label paper match the case interior so that the objects displayed on the boxes, through their contrasting color, assume more importance than their supports. The "architecture" of an exhibit (the structures that hold the items in place) should never become so interesting in itself, or so dominant, that the exhibit materials are lost in a maze.

Sometimes the case furniture is made to reflect the subject matter. The timbering used in mines is used here to exhibit minerals.

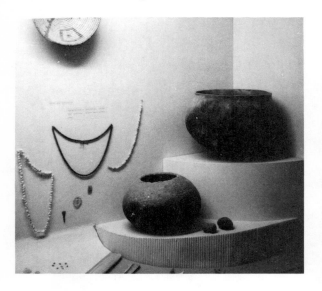

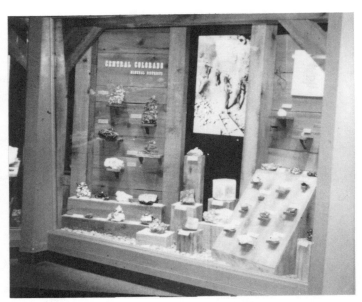

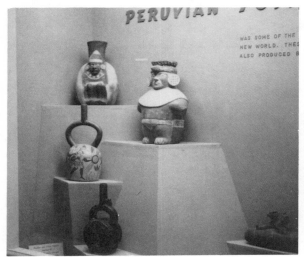

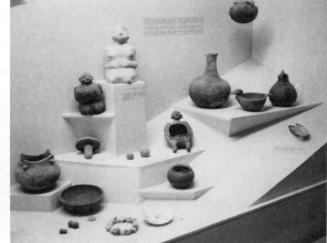

Panels

The use of panels in corridors already has been discussed. Panels have additional uses in exhibit rooms as well, where they may serve as directional devices, as supports for information, or may form a free-standing wall.

It is not necessary that panels be a single, flat plane. They acquire more visual interest if they combine two or more planes, have additional areas added to their surfaces, or have small exhibit cases fastened on the front or behind framed openings.

These photographs and sketches show only a few of the many variations of panel uses one may design.

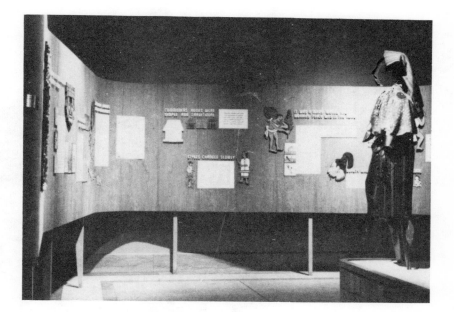

Curved plyboard panel provides area for information and acts as a directional device in exhibit at the University Museum, University of Pennsylvania, Philadelphia, Pennsylvania.

Spring-loaded poles support light-weight panels at the St. Louis Academy of Science, St. Louis, Missouri.

Shallow, lighted exhibit boxes mounted on back of panels display selected artifacts.

burlap

FRONT

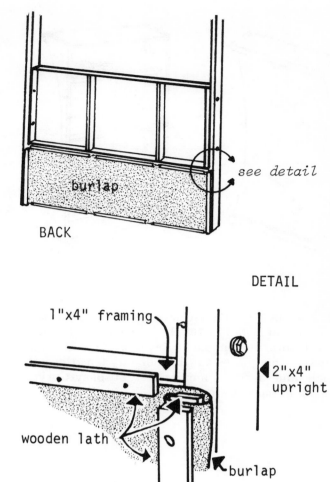

burlap

see detail

BACK

DETAIL

1"x4" framing

2"x4" upright

wooden lath

burlap

Simple panel of 3/16" by 4' x 8' Upson board glued and nailed to 1" x 4" framing; bolted to two 2" x 4"s which are capped by spring-loaded units (Brewster's "Timber Toppers") to hold in vertical position. Colored burlap stretched across bottom is held in place with wooden laths.

1/8" sheet of 4' x 8' Easy-Curve mounted on curving supports cut from 1" x 10" shelving with additional 1" x 4" bracing on back. Reverse curve is constructed from pieces cut from one-by tens (for left panel) and an additional sheet of Easy-Curve. Bracing in back is similar.

Additional support made of ¾" pipe. Floor flanges fasten pipe to panel bottom framing and to plyboard disc which rests on floor.

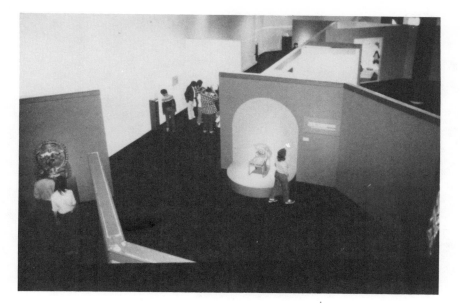

Panel walls define a traffic pattern.

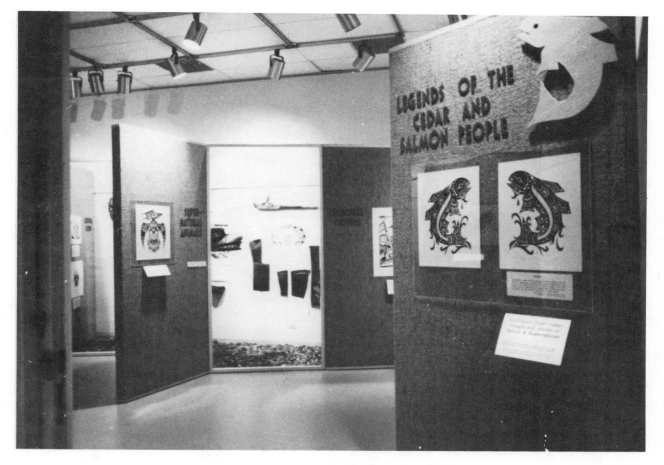

Solid panels are combined with "window" panels.

Plexiglas boxes protect artifacts mounted to wall panels.

Panels create a "room within a room" where basic ecological concepts are displayed.

"PROBLEMATICAL" OBJECTS—What to do with a gun collection

Too often displays of guns in historical museums resemble an illustrated catalogue in three dimensions.

Only gun lovers could find these two exhibits of interest and they would have difficulty seeing details of the exhibited specimens!

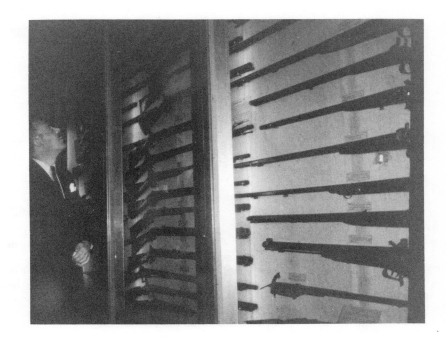

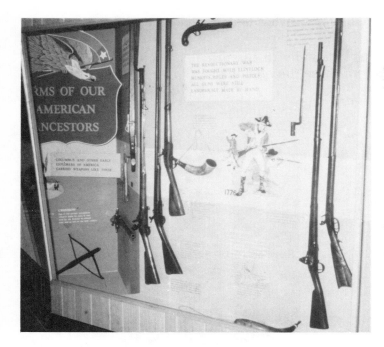

Gun Exhibit, New Illinois State Museum, Springfield, Illinois.

When the Illinois State Museum acquired a new building, their old gun display (lower picture, page 75) was discarded for a completely new approach.

The new gun exhibit is one of the best this writer has seen. The important developments in firearms are tied in with the history of the country by the use of a continuous time-line and key illustrations.

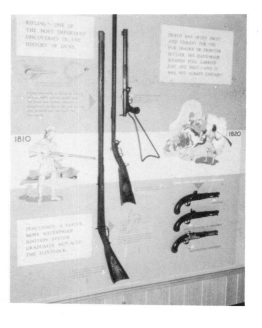

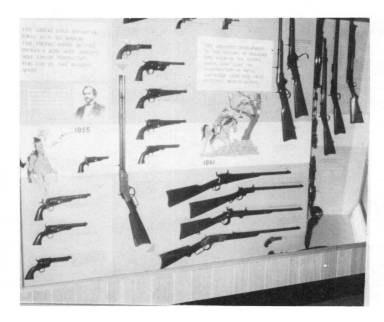

The resulting exhibit is of interest to many people who might otherwise find a gun display dull.

Duplicate guns have been retired to an available study collection.

"PROBLEMATICAL" OBJECTS—What to do with old farm implements

Without some kind of organization and interpretation old farm implements have little meaning for today's young people.

An approach to understanding is provided if no more is done than to group tools with similar functions together on common panels. (One might wish the labels had been printed on less conspicuous paper.) Use of textured wood and massive vertical supports (suggesting barn construction) is pleasant and appropriate.

Photo courtesy of Kansas State Historical Museum, Topeka, Kansas.

Placing the implements in a stylized farm setting conveys an immediate impression as to general function. The platform serves a double purpose: it raises the machinery and tools to a more accessible viewing height and discourages the visitor from stepping into the exhibit area. A layer of gravel on the platform surface is visually pleasing and has the advantage of showing little dust and dirt.

Photo courtesy of Kansas State Historical Museum, Topeka, Kansas.

At the Farmer's Museum in Cooperstown, New York, rural implements of the early nineteenth century are arranged according to "The Farmer's Year." For each section a large panel provides an introduction with the name of the month and a headline label. Appropriate equipment for the season is shown with samples of crops, printed advertisements and other associated items. One section label reads:

JULY
Hay-making

Hay was formerly one of the chief crops of our state. Timothy and clover were grown to feed the thousands of horses on the farms of towpaths, turnpikes and towns.

Everyone available took part in hay-making. It was usually cut and left to cure, then piled up on large stacks or put into barns. In poor hay years the animals would winter on corn stalks or grainstraw, or else the farmer was obliged to butcher them.

78

"PROBLEMATICAL" OBJECTS—Period rooms

Period rooms, which are constructed to re-create the feeling of a particular historic time, often are presented in a series similar to the street window displays of department stores or full-scale versions of a one-story doll house. They are used best when they are incorporated with a variety of other visual techniques as a working part of a larger story. Panels and cases on each side of the period room can highlight small items, giving the visitor an opportunity for closer scrutiny while associating the objects both with the time period and the specific room.

The log house interior shown below, is placed across the end of the corridor in the permanent exhibit "Life on the Prairie" at the Joslyn Art Museum, Omaha, Nebraska.

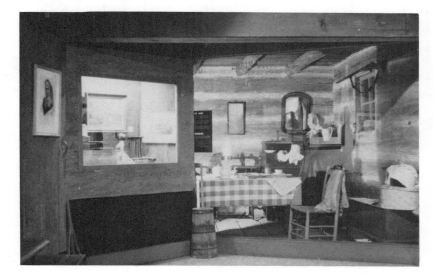

Sometimes the same emotional response may be evoked by a simple layout in a shallow case. Full background paintings with related objects dramatize the back-breaking chores of a pioneer housewife in these two exhibits in the Nebraska State Historical Museum, Lincoln, Nebraska.

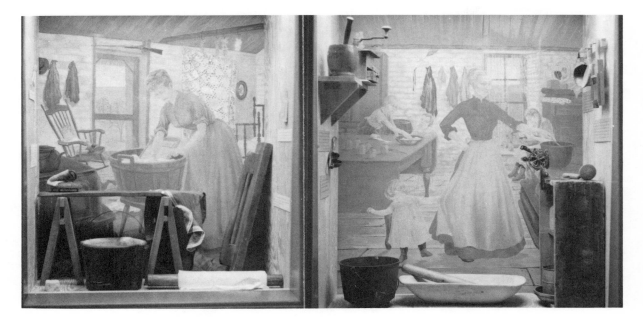

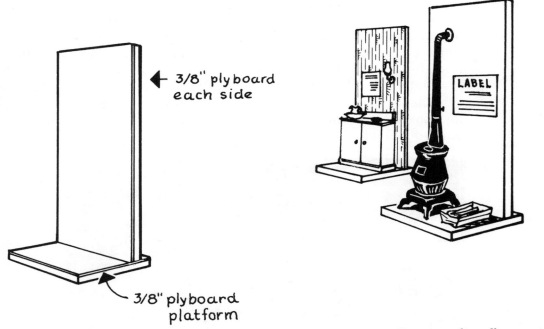

← 3/8" plyboard
each side

3/8" plyboard
platform

Free-standing floor units.

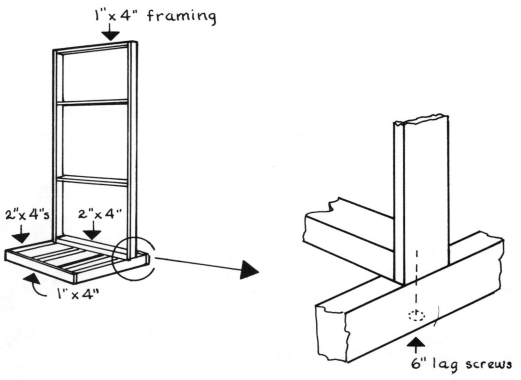

1"x 4" framing

2"x 4"s 2"x 4"

1"x 4"

6" lag screws

80

Panel and platform combinations may be used to present large, heavy, or bulky objects and, by use of appropriate wallpaper and other accessory items, can provide an inexpensive but effective approach to the period room concept.

The units shown on the opposite page may be distributed as "island" units in a room. Fully finished, the backs provide areas for display of flat visuals—maps, photographs, and paintings—while the fronts create space for large objects. The units are useful for exhibits of heavy machinery such as early farm equipment or engines as well as for furniture.

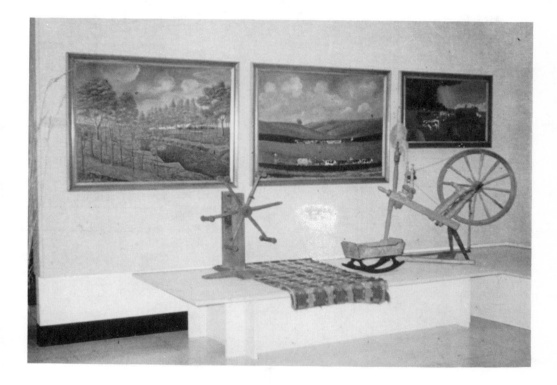

The wall and platform combination shown above functions well at the Illinois State Museum in Springfield. Primitive American paintings shown with contemporary arts and crafts create a definite mood and feeling for pioneer times.

PANELS and PLATFORMS

are combined to
exhibit bulky
objects.

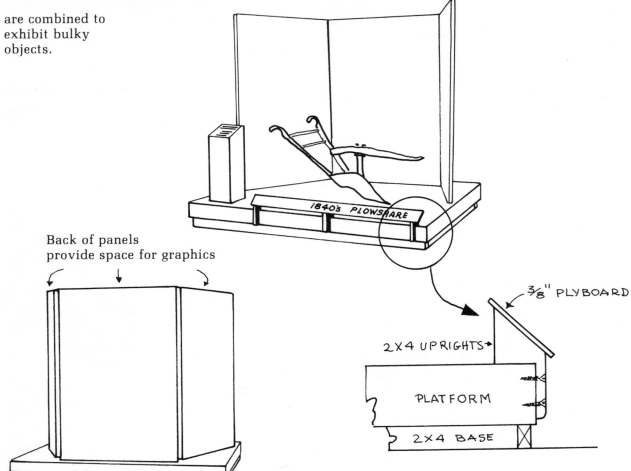

Back of panels
provide space for graphics

2×4 UPRIGHTS→

3/8" PLYBOARD

PLATFORM

2×4 BASE

1840's PLOWSHARE

LABEL

Hanging a chair on the peg
board shows one typical
Shaker custom . . . and
creates space for a label.

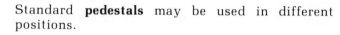

Standard **pedestals** may be used in different positions.

Two sizes are shown here:

 18" x 24" x 36"
 18" x 18" x 30"

Panel combined *with* **pedestals.**

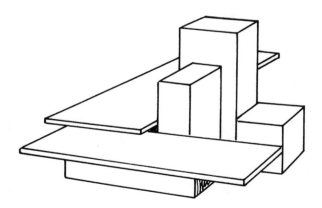

Panels may become **platforms**.

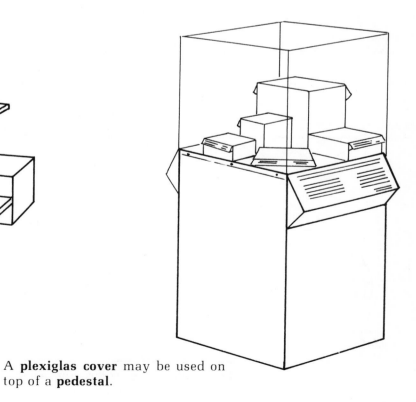

A **plexiglas cover** may be used on top of a **pedestal**.

INTERPRETIVE WALL DISPLAY

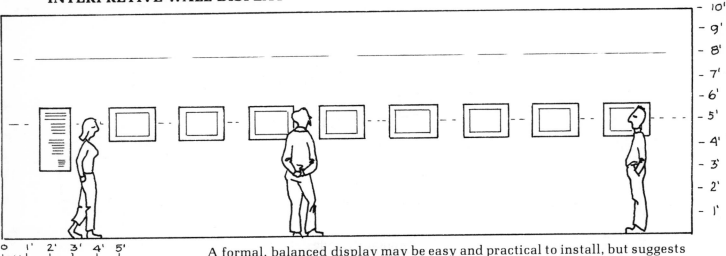

A formal, balanced display may be easy and practical to install, but suggests all materials are equal . . . and is monotonous.

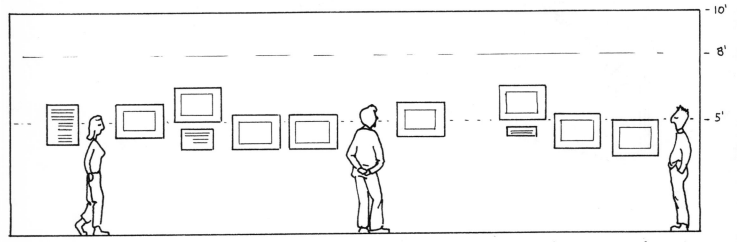

Materials should be grouped to show relationships (subject, time, style, etc.), and groupings arranged in clusters. Lining up by linear components (horizontal or vertical frame outlines or mat edges) helps viewers' eyes to "sort" and perceive materials.

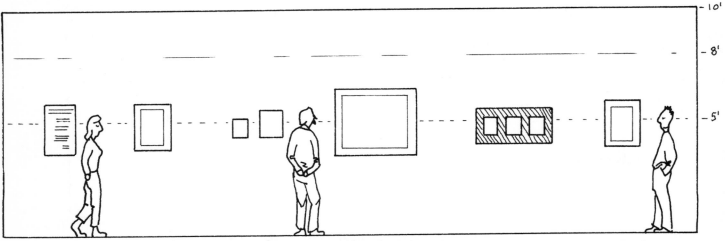

Size, blank space, color, line, shape and texture are used to emphasize, indicate, separate and combine.

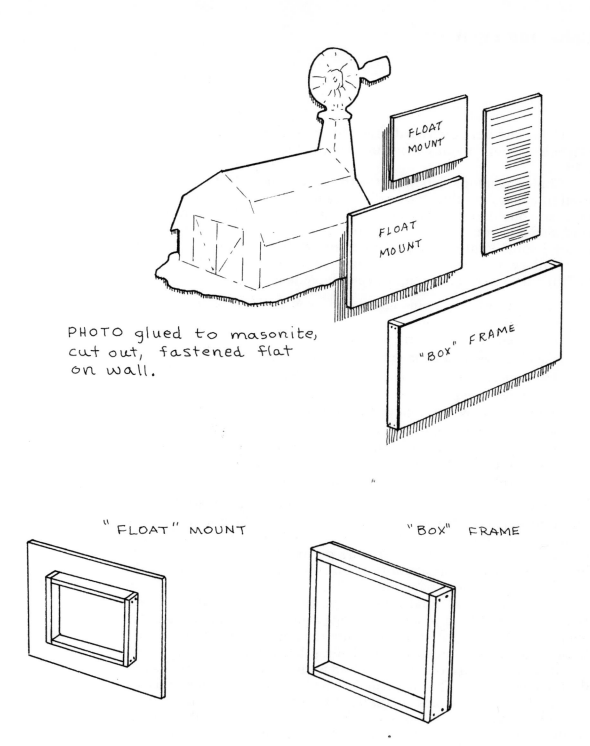

PHOTO glued to masonite, cut out, fastened flat on wall.

FLOAT MOUNT

FLOAT MOUNT

"BOX" FRAME

"FLOAT" MOUNT

"BOX" FRAME

It is not necessary, always, to mount graphic materials flat against the wall. Interesting variations can be created by using a combination of flat, "floated," "box" framed and cut-out display techniques.

Color and Light

Color and light are two design factors which, though inexpensive, can enhance any display when used with imagination and discrimination.

Choice of color starts with the theme and the objects that are to be used in conveying that theme. Gallery or hall walls, floor and ceiling may be considered a "background" for the presentation and should complement, not compete with, the specimens on view. Some very general considerations regarding color are listed below.

Gallery wall colors can suggest a natural environment or an architectural period. Examples seen have been:

light and dark grey stains on textured wood used in a mining exhibit in an historical museum;

"barn" red used with farm machinery;

pale blue used in a room exhibiting Eskimo artifacts;

clear yellow walls in a room of Plains Indian materials;

very dark green behind Iroquois false faces (which were suspended by nylon fishing line, lighted by concealed spots);

sandy buff in an Egyptian hall;

aqua blue (more a blue than turquoise) in a gallery of classic Mediterranean cultures;

deep purple, white and gray with exhibits of Medieval armor.

Varying shades of the same basic color may be used to unify different aspects of a general subject; e.g., a light blue background might be used for pre-Civil War military exhibits and a darker blue for cavalry displays of the Indian wars period. Both subdivisions might have several case exhibits but the unifying wall color would tie them together visually and psychologically.

Color can help visually to change the size and shape of a room. Dark walls will tend to shrink a huge room; light ones will expand a small one. A dark wall at the end of a long, narrow room will give the impression of shortening and widening that room.

If the ceiling of a room is cluttered with pipes or unsightly beams, a dark color—even a flat or satin-finished black—will make the pipes and angles of the beams virtually disappear. A light-colored ceiling will add visually to the height of the room. In a hall exhibiting birds, walls were painted varying shades of beige (according to land areas occupied by the birds shown) and the ceiling was painted a sky blue. Coves above the case walls provided an indirect source of light for the ceiling which appeared much higher than its actual height.

Specific case colors should be chosen in relation to the objects displayed in the cases. A dark-colored case will make light-colored materials appear larger than they are by the contrast; a light-colored case will make dark materials look smaller.

If in doubt, use of a background complementary color (those shown on opposite sides of a color wheel) usually is safe.

Certain colors (hues of red, orange and yellow) seem "warm" and tend, visually, to advance while others (the various blues) appear "cool" and seem to retreat. Green and violet hues are halfway between warm and cool, and vary in their tendency to "advance" or "retreat" according to the proportion of warm or cool colors they contain.

When colors for the gallery walls and cases have been chosen, a few accent colors may be used on the three-dimensional letters of the headline label or sparingly to attract attention to key parts of the installation. Care should be taken, however, not to combine too many colors nor to use too many "accents" in a single display. As with gallery planning or case layout, simplicity is more successful than complexity.

Many paint companies maintain a staff interior decorator whose advice may be free. If in doubt, it is wise to seek this professional help.

Light

Controlled light can do much to create a mood, change visual pace, indicate an historic period or a natural environment, and can aid in visitor circulation through the use of proper placement and direction. Daylight, streaming in through windows, is uncontrolled and may vary from dazzling brightness on a sunny day to a dull, flat grayness when the weather is overcast. Ideally, museum *exhibit areas* should be windowless, permitting complete control with artificial light.

In old buildings which are lined with windows, exhibit rooms may be improved by painting the windows to block out the light. If the gallery is planned with false walls which are placed at least four or five feet away from the room wall, light from the windows will be effectively shielded and diffused.

Both fluorescent and incandescent lights may be used (sometimes in combination) to good advantage. Most rooms will receive enough illumination from lights inside the display cases. Where large wall areas are to be lighted evenly (as in a picture gallery or wall-panel arrangement) fluorescent lights mounted in a cove or wall bracket provide a "wash" of light. (See construction section for details of

wiring and installation.) Fluorescent lighting is economical, providing almost three times as much light as incandescent for the same power consumption. It yields a "soft" diffused light which minimizes shadows and burns with less heat than incandescent.

"Deluxe Cool-White" fluorescent lamps make colors appear almost as they would in daylight; "Deluxe Warm-White" lamps provide a "warm" light approaching the color of incandescent lamps which emphasize reds, oranges and yellows. Great care should be taken in the selection of fluorescent lamps in order to get the best color rendition and, once a definite lamp has been chosen, the effort must be made to replace burned-out lamps with exactly the same type in order to maintain the original color effect. It is wise to plan and paint gallery walls and case interiors under the same lighting conditions as will be operating regularly.

The following chart shows some of the color changes which may be anticipated with various lamps:

Painted color	Incandescent	Fluorescent		
		Standard Cool-White	Deluxe Cool-White	Deluxe Warm-White
Light yellow	Vivid yellow-orange	Bright yellow	Bright yellow	Deep yellow
Medium Blue	Blue-green	Gray-blue	Reddish-blue	Purple-blue
Cherry red	Bright red-orange	Yellow-red	Cherry red	Orange-red

Fading of displayed material is another factor to consider in use and placement of light. Fluorescent lamps should be at least twelve inches from the front surface of any fabrics, paintings, or color-printed pages. *Translucent plastic tubes (known as ultra-violet, or UV sleeves) must be slipped over fluorescent lamps* to help reduce fading.

Incandescent lights provide sparkle and color in exhibits of gems, jewelry and cut crystal. Specific highlighting of large floor displays such as sculpture, historic vehicles and machinery may be accomplished with the use of reflector spots and floodlights. The Swivelier Company, Inc. manufactures a porcelain swivel-socket which may be screwed into an existing porcelain socket to provide a heat-resistant, directional device for reflector spots and floods.

The combination of a fluorescent lamp for general lighting with emphasis on a key specimen provided by a low (75 watt) wattage reflector spot may be used inside some case exhibits. Care must be taken to provide for adequate ventilation and air circulation whenever incandescent lights are used inside a case.

Many different display lighting fixtures and systems are available to the exhibit designer. Check the materials and suppliers section of the current *Museum Directory* (published by the American Association of Museums) and write for information.

General illumination from an overhead fluorescent light.

General overhead illumination plus hard side light.

Hard side light with less overhead light creates shadow and more dramatic effect.

Diffused side light deepens mood but lessens comprehension of object.

Labels

A label is a sign. It informs; it explains; sometimes, it directs. It is not, and should not pretend to be, a book. It should be concise and written in simple, direct, uncomplicated, and unpretentious language. Because labels usually will be read by standing people, and because most people are not physically conditioned for this, the important part of the label should be at the beginning.

If labels are arranged like a newspaper's headlines and stories, many visitors will read them. Some people read only the headlines. Some read headlines and subheads. Still others read everything, including the classified ads and obituaries. Labels can be designed to satisfy all groups.

A well-designed gallery will be arranged in a sequence so that each display is a part of a continuous story. Logically, in such a gallery there will be the following labels:

1. A large sign placed at or near the entrance which informs the visitor of the contents of the room. If, for example, the area is full of old glass, the "room label" or "gallery label" permits those people for whom old glass holds no attraction to save their feet and eye muscles for exhibits in which they *do* have an interest. Letters forming this label may be three-dimensional and should be at least four inches high.

2. Each case or panel exhibit will have a large "headline" label which will serve the same function as the headline of a newspaper. It will attract attention, focus interest on the case, and will be short and to the point. To be read easily, it may be the main phrase, emphasized by size, in an introductory sentence (as shown in the Hopewell culture label). These headline labels should be written in such a

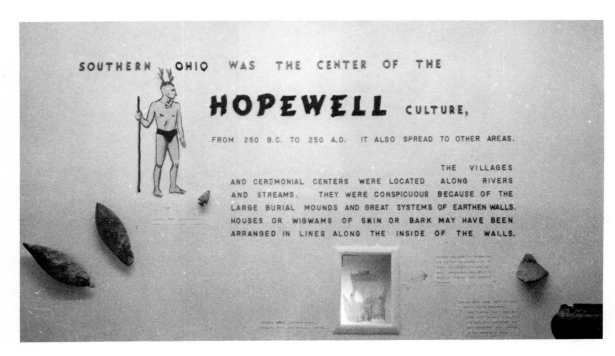

SOUTHERN OHIO WAS THE CENTER OF THE

HOPEWELL CULTURE,

FROM 250 B.C. TO 250 A.D. IT ALSO SPREAD TO OTHER AREAS.

THE VILLAGES AND CEREMONIAL CENTERS WERE LOCATED ALONG RIVERS AND STREAMS. THEY WERE CONSPICUOUS BECAUSE OF THE LARGE BURIAL MOUNDS AND GREAT SYSTEMS OF EARTHEN WALLS. HOUSES OR WIGWAMS OF SKIN OR BARK MAY HAVE BEEN ARRANGED IN LINES ALONG THE INSIDE OF THE WALLS.

manner that the visitor who reads only these labels may still gain a narrative account of the total story told by the exhibits in the hall. The headline label is usually made up of three-dimensional letters of two sizes.

3. Secondary labels follow the headline and take the function of the subhead of a newspaper, containing a little more detail and expanding the information. These letters usually are also three-dimensional but are a smaller size than letters used in the sentence and main phrase of the headline label (also illustrated in the Hopewell label).

4. Specimen labels, which go with each object on view, then continue the story in detail. The leading sentence in the specimen label should be a topic sentence (which may be emphasized by using bolder type or a three-dimensional letter), and the rest of the paragraph should explain further the statements contained in that sentence. Where several objects are similar, a long label can be written, then divided, and some portion of it put with each object. The topic sentence of this long label should serve to group the objects together under one general heading within the case. As an example, in a display that included many kinds of old bottles, a topic sentence might read:

"It is sometimes possible to date the occupancy of an abandoned house by the kinds of glass fragments found within it."

The remainder of the label could explain early methods of manufacture and how they can be recognized, and the items of glass would serve as illustrations to the label. The long label would be physically divided (cut apart) and a portion placed with each appropriate object. Visitors are invariably more interested in **what** a thing is, **who** made it, **where, when, how** and **why** it was used, than they are in the fact that Joe Smith gave it to the museum in 1928 and that it originally cost him ten dollars.

It is regrettable that many art museums continue simply to hang their permanent collections of prints and pictures on their walls and to display their sculptures on floor stands accompanied only by labels that name the artists, the dates when they lived, and the name of the donor. How much more effective would be art exhibitions that included introductory labels to explain the basic facts of various art movements and transitional labels to show their development. The attempt to place artists and their various "schools" within a frame of reference understandable to the untrained layman might result in support for the art museums' programs coming from totally unexpected sources!

When laying out titles and text, it is very easy to become so interested in the design of the total letter and word area that an interesting pattern which uses the words as decoration may result. This does not necessarily mean that the words themselves are easy to read. *When words are split up and used as decoration, or are arranged at odd angles in a mistaken striving for "effect," they are awkward to read and their meaning becomes difficult to grasp.* Use of tricky, cute, or unusual type is never justified if it is being used *only* for the sake of being different. If an unusual type face really helps to communicate— fine. Otherwise, remember that your labels are designed with just one purpose in mind. You want people to read them.

Words used as decoration
may be awkward to read.

It is a good idea, once one or two type faces have been chosen for a particular gallery, to use them consistently without adding more styles. Too many styles within a given area will prove distracting.

The best label is one which is so well written, arranged, and lettered that it leaves the visitor almost unaware of technique and able to concentrate on the meaning of the words.

Instructions for making three-dimensional alphabets, hand-lettering, the use of stencils, "Instant" type (dry transfer letters) and other labelling techniques are given in the Construction Methods Section.

Part II:

CONSTRUCTION NOTES

Introduction

Many museum presentations may be built by the dedicated volunteer who is a week-end carpenter. Often, these constructions may serve the small museum better than the expensive commercial units that are available. Some ideas on construction are presented in this section.

Perhaps more than anything else in construction, the museum exhibit builder should consider *ease of maintenance*. No exhibit will remain fresh-looking forever. How lights are to be changed, colors touched up, and out-of-date labels replaced should be major factors in any design.

Since the first edition of *Help!* appeared, the profession has become much more conscious of the need to consider *conservation of the object being put on display*. It is most important to check current conservation practices when planning exhibits. A list of regional conservation centers is included in the appendices. I urge all exhibit people to consult with their local or regional experts.

Tools

Buy the best quality made.

Take proper care of them.

BASIC HAND TOOLS

Claw hammer

Nail set

Claw Hammer

A bell-faced hammer has a slightly rounded face and is recommended as a beginning tool because a nail can be driven flush with the wood without leaving hammer dents. Buy one made of drop-forged tempered steel. Cast heads may chip or break and are dangerous to use. Handles are usually of hickory, steel, or fiberglass, all of which are recommended. Two weights (which refers to the weight of the hammer head) are useful: the 16-ounce is used for heavy-duty, all-purpose hammering; the 10-ounce for lighter, more delicate work.

A few working tips:

Hand should be toward base of handle. When head hits nail, handle should be at right angle to shaft of nail.

Nail set should be used with *all* brads and finishing nails. Spackling paste is used to fill the hole before the wood is painted. Plastic wood may be used if the surface is to be stained.

A piece of light-weight cardboard (such as shirt cardboard from the laundry) is used to start a small nail. Push the nail through the cardboard. Hold the cardboard and, when the nail is driven almost flush, tear cardboard away before the final blows are delivered.

Before trying to drive a small nail through hardboard, such as Masonite, drill a small hole. (Clip the head off a small nail of the same size you intend to use, and use this nail for the drill.)

Slip a scrap of wood under the claws of the hammer to increase leverage and to help prevent damage to the wood surface when pulling out a nail.

Hand Crosscut Saw

Saws are measured by length and by the number of teeth (called points) in an inch. The number of points is usually marked on the blade. A 24-inch, 10-point saw is a good general-purpose size.

Marks of a good saw: it should be flexible, the blade made of tempered spring steel so it may be filed and sharpened; the edge with the teeth should be thicker than the back to provide firmness at the cutting edge and clearance for the rest of the saw in the "slot" (called a kerf) being cut; the blade surface should be ground and polished and the handle should be made of hardwood fastened with brass rivets.

A few working tips:

Use the knuckle of your thumb to guide the saw when starting the cut.

Remember the saw has a thickness and cut on the waste side of a measured line.

Use a combination square to insure a true right-angle cut.

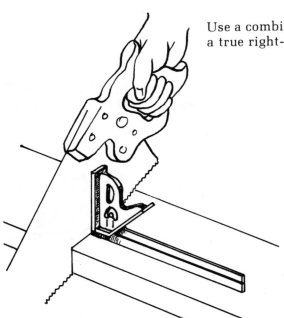

A long 2 x 4 board which is straight and has true right-angle sides is clamped with C-clamps along a line to make accurate long cuts from plyboard sheets. Slip scrap cardboard between the jaws of the clamps and the plyboard surface to protect the wood.

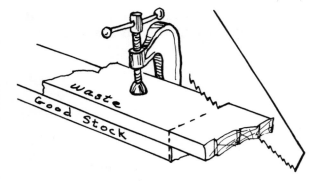

A thin edge may be trimmed from the end of a board by clamping waste stock to the board and sawing through both pieces. Protect the good stock from clamp dents by using scrap cardboard between the clamp head and the board surface.

Hack saws are used to cut metal such as steel and aluminum angle-iron and bars, aluminum tubing, pipe or conduit, and to trim bolts. Two styles are shown: a wing-nut tightens blade tension on the heavy-duty saw shown above; the handle tightens the blade on the saw below. Blades are inserted with the teeth pointing away from the handle and a blade with eighteen teeth per inch is best for general use. A blade with thirty-two teeth per inch is used for thin material.

Starting the cut is easier if a nick is made in the metal surface with a file.

Clamp a thin sheet of metal between two pieces of wood (in a vise or with C-clamps) to saw without bending the metal and to get a clean cut.

Thread a nut onto a bolt before sawing the bolt to correct length. The nut may be held in a vise and, when the cut has been made, the nut cleans the bolt threads as it is removed.

Coping saw

Coping saws are used to cut intricate, irregular and curved shapes in thin wood, hardboard, cardboard, plastic and sheet metal. Blades have pins through each end which catch in slots, and are mounted in the frame with teeth pointing toward the handle. Tension is maintained by tightening the handle and most saws are adjustable so that the blade may be rotated in the frame. Many blades are available, from those with eight teeth per inch and about one eighth of an inch wide, to those with thirty-two teeth per inch and less than one sixteenth of an inch wide. A spiral blade is also on the market, which makes it unnecessary to change blade direction while cutting. Heavy, coarse blades are used with wood and plastic; fine, thin blades work well with cardboard (several layers of which may be stapled together for multiple copies), hardboard and metal. (See use of coping saw in section on making three-dimensional alphabet letters.)

Keyhole saw for wood

Keyhole saw for metal and wood

Back saw (used with mitre box)

Keyhole saws can be used to cut gently curving lines in plyboard; to cut out large holes in the middle of plyboard sheets; to cut openings for pipes and electrical outlets. The narrow, tapered blade can cut in places where other saws cannot be used. Some types come with interchangeable blades.

A back saw is used with a miter box to cut moldings for glass, case opening trim, frames for prints, photographs, etc. The reinforced back provides rigidity and the blade, which can range from ten to twelve inches in length, may have ten to fourteen teeth per inch. A useful size is twelve inches long with fourteen teeth per inch.

Inexpensive wooden miter boxes may be purchased with slots for ninety degree and forty-five degree cuts.

Phillips screwdriver

Offset screwdriver

Screwdrivers are probably the most abused tools in any tool kit.
They should never be used as chisels, paint-can openers or pries. They
should be used *only* for driving screws. Buy good ones with handles
large enough to grip. A basic set would include: a No. 2 with a 1/4-inch
blade, No. 3 with a 5/16-inch blade, and a No. 4 with a 3/8-inch blade.
Adding one small and one medium size Phillips screwdriver for
Phillips-head screws (with a cross instead of a straight slot) and a Z-
shaped offset screwdriver for work in close quarters will complete a
first list of necessary screwdrivers.

Always use a screw tip that *fits the slot* of the screw. An oversize
tip will chew up surrounding wood when the screw is forced in; an
undersize tip will not distribute enough force to turn the screw and will
become rounded when it slips out of the screw slot. The screw tip
should completely fill the slot and should *not* be rounded or beveled.

A small hole should be pre-drilled into the material before the
screw is driven to avoid splitting the wood. If a screw is hard to drive,
try coating the threads with soap. If it is still difficult to turn, back it
out and enlarge the pilot hole. Forcing it may break it off in the hole.

Pliers

Pliers (with jaws slipped for wider grip)

Pliers

Round-nose, slip-jawed pliers are most common and are used in a variety of holding jobs. Fine grooves at the rounded tip hold small objects, larger grooves farther back hold nuts and bolts and round objects (pipe or tubing). To grasp larger objects slip jaws wide until the pivot bolt slides into other hole.

The grooves of all pliers should be kept clean.

Other useful pliers include:

Combination pliers—
a heavy squared nose combined with wire-cutting action;

Narrow-nosed—helps to hold and remove brads, pins; may or may not be equipped with wire-cutter.

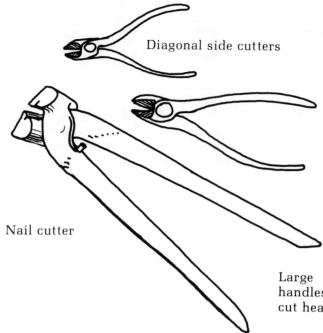

Diagonal side cutters

Nail cutter

Diagonal side-cutters (ranging from small model-makers' tools to 8-inch long carpenters' size) are used to cut off nail and brad heads and pins and to cut lengths of various wires.

Large nail cutters (with 10-inch handles) provide enough leverage to cut heavy nails and wire.

Measuring Tools

Flexible steel tapes are made in 6-, 8-, 10-, and 12-foot lengths; ½-inch or ¾-inch wide. For most use a 10-foot long, ¾-inch wide tape will be practical. Buy a tape that has a locking action. When the tape is released to return to the case, stop the action about two inches from the end of the tape and feed the remainder in slowly so as not to rip off the rivets attaching the little end tab.

A combination square has a sliding head, tightened by a thumbscrew which makes the tool useful in a variety of ways: to check if ends of boards are square (and provide a rule against which to draw a true right angle if the board is crooked); it can be used as a depth or marking gauge; can be used to lay out a forty-five degree angle and to check right angles on a frame.

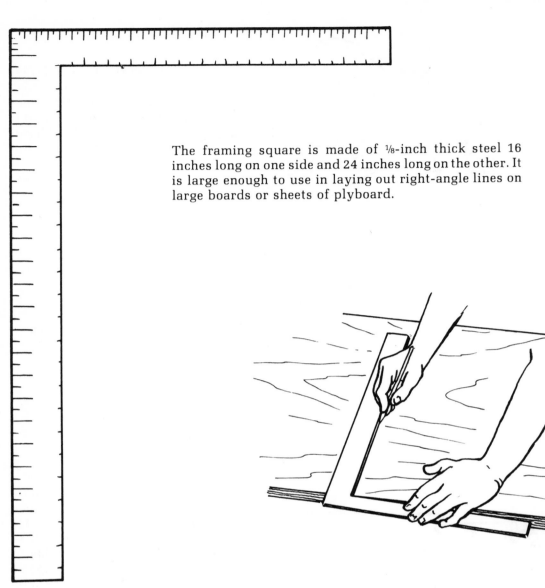

The framing square is made of ⅛-inch thick steel 16 inches long on one side and 24 inches long on the other. It is large enough to use in laying out right-angle lines on large boards or sheets of plyboard.

For accuracy, the *inside* edge of one leg of the "L" is lined up on the edge of the plyboard panel.

An aluminum carpenter's level, 24-inches long, provides an accurate check for horizontal placement of all cardboard, plastic, or plaster label letters, printed labels, mounting of picture frames, brackets, or picture moldings.

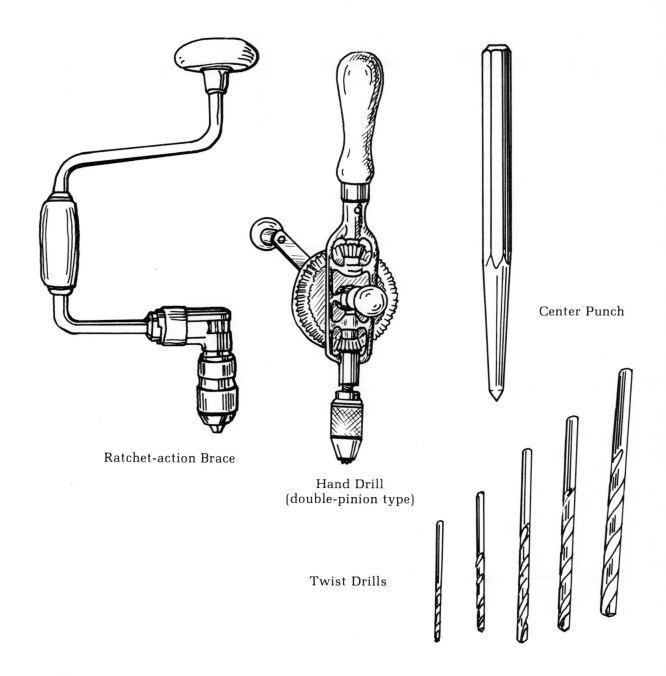

Ratchet-action Brace

Hand Drill
(double-pinion type)

Center Punch

Twist Drills

Electric drills have nearly replaced the use of the brace and bit and hand drills, but these are still useful tools to include in any basic set. The hand drill is used for lightweight work, to drill holes for screws, nails, etc. The double-pinion type (with gears on opposite sides of the drive wheel) is sturdy and long-lasting. The brace should be a rachet type to permit heavier work in close quarters.

A center punch should be used to make a starting dent in any material before drilling.

Twist drills come in sets of eight, from 1/16-inch to 11/64-inch and are used with both the hand drill and electric drill. Buying cheap sets is false economy, for the drills will become dull almost with first use and may bend or even break with little pressure.

Wood Auger

Screwdriver Bit

Countersink (for wood and
other soft material)

Countersink (for iron, mild
steel, and soft materials)

Wood augers come in short, medium, and long lengths as well as in a variety of diameters. Use the shortest length practical to gain the greatest control of the tool.

One of the most useful accessories for the brace is the screwdriver bit. Several sizes may be purchased. Where a project involves placement of a quantity of screws, holes for the screws should be drilled first, the screws well started with a hand screwdriver, then the brace with screwdriver bit used to complete driving the screws. Use of the brace permits fast work and, if a large screw is difficult to turn by hand, the brace provides greater leverage.

Smoothing plane

Planes most commonly are used to smooth rough places, to bevel edges, and to trim oversize pieces. While many sizes and styles of planes are made, the smoothing plane and block plane are most useful for general work. When using the smoothing plane, be sure to check the grain of the wood and plane *with* the grain and not against it.

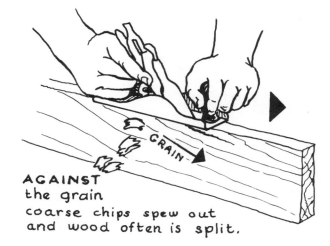

WITH the grain — smooth, even ribbons curl out.

AGAINST the grain coarse chips spew out and wood often is split.

Block plane

The block plane, with a blade set at a low angle, is particularly useful for trimming and smoothing end cuts across the grain. Work from the corners to the middle to avoid splitting wood.

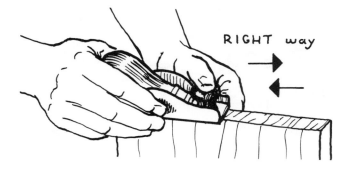

RIGHT way

WRONG!

ADDITIONAL USEFUL HAND TOOLS

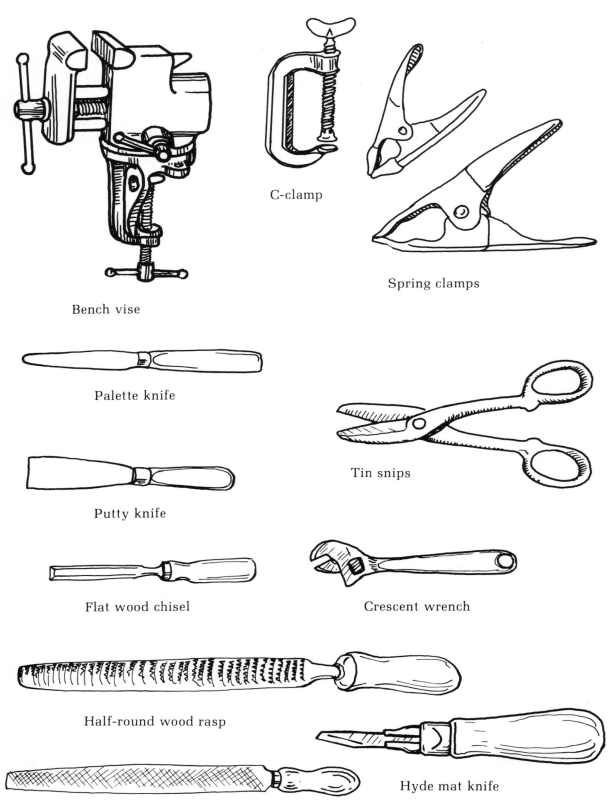

C-clamp

Spring clamps

Bench vise

Palette knife

Putty knife

Tin snips

Flat wood chisel

Crescent wrench

Half-round wood rasp

Hyde mat knife

Mill-bastard cut file

110

BASIC POWER TOOLS

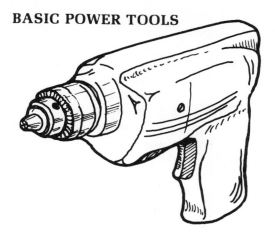

Electric drill

Combination Wood Drill and Countersinks

Countersink

Portable electric saw

Saber or jig saw

Cutawl

Basic Power Tools

While all construction can be accomplished with hand tools, power tools increase accuracy and reduce the time necessary for the same work. Just as with hand tools, buy the best quality you can and take proper care of them. Cheap power tools will burn out quickly. Being made of light weight materials, they will get out of line and, by failing to deliver accuracy when it is expected, create frustrations and disappointment.

The electric drill is one of the most versatile tools available and should be the first power tool purchased. Size of the drill indicates the largest diameter of shank that can be held in the chuck. Recently, ⅜-inch drills have taken over some of the popularity reserved for the earlier ¼-inch "home handyman" drills. A ⅜-inch drill with variable speed control, speeds from 0 to 1,000 RPM, a motor developing up to 1/3 HP, equipped with a Jacobs chuck (a geared chuck tightened by a geared key, *not* a hex-key) will provide a dependable source of power not only for basic drilling operations, but also for a variety of attachments.

Bits available for use with the electric drill range from the 1/16-inch twist drill to a 1-inch spade bit. Adjustable expansion bits, hole saws with pilot bits, and combination wood drills and countersinks increase the usefulness of the tool.

With the use of well-made attachments, this versatile tool can be changed into: a jig or saber saw, circular saw, sander, grinder, polisher, lathe, or drill press. A wire brush (bristles come in soft, medium, or hard) can be used with the drill to clean rust from metal, or sculpture a textured surface into plyboard.

The greatest enemy of the drill, as with all power equipment, is dust. Keep the drill in a dust-free cabinet or case, or covered, and follow the manufacturer's directions for proper lubrication and maintenance.

As finances permit, the power saber (or jig) saw and portable electric (circular) saw should be added to shop equipment.

The saber saw makes it possible to cut curved lines in heavy plyboard sheets, window openings in plyboard panels, as well as performing most hacksaw jobs. New heavy-duty models are equipped with variable-speed motors (which develop 1/3 HP), increasing the control and power of the saws. Quarter-inch shank blades range from 2¾-inches to 3½-inches in length with from six to ten teeth per inch for wood cutting, to eighteen and thirty-two teeth per inch for metal work.

A 7½-inch (which refers to the diameter of saw blade) industrial-duty circular saw with ⅝-inch arbor and 2 HP motor will greatly reduce the time and effort needed in trimming 2 x 4 and other framing lumber, and cutting full-sized plyboard sheets. Standard combination blades are designed for all types of wood, with and across the grain. Special plyboard blades considerably reduce the amount of splintering when plyboard or thin veneers are cut. Both the combination and plyboard blades should be sharpened and set by a professional. Some companies carry disposable blades which cannot be sharpened or set, but are inexpensive enough to throw away and replace when they become dull. These blades remain sharp and effective for a surprisingly long time.

Never run a saw blade (circular **or** saber) **through any nails, screws, or bolts.** (It will ruin the blade and may cause an accident.)

The cutawl is an amazing cutting tool which works with a pivoting, reciprocating chisel or blade. It is used in as widely divergent industries as garment manufacturing, where it cuts through many thicknesses of fabric at a time, to department store display and industrial trade-fair exhibit shops, where it may be used to cut intricate scroll work (as fine as a jigsaw puzzle) or sheets of Upson board for theatrical stage-sets. If your local department stores have their own display shops, ask if you may see the cutawl demonstrated. For information about the tool, write: The Cutawl Corporation, Bethel, Connecticut 06801.

The following useful power tools may be added to the basic equipment as funds are available: orbital sander, jig-saw, radial-arm saw, table saw, and router.

Materials

Most exhibits are built with some combination of framing lumber (for strength) and panel surfacing.

FRAMING MATERIALS

Pine provides the best framing material. Fir is also used (as in 2 x 4s), but splits more easily than pine. Use the least expensive grade that will serve the purpose. "Clear" or "select" is the highest quality and is required *only* when the framing will show and the materials are to be stained rather than painted. The other "finishing" grades are: C Select—next in quality—may have pine knots and minor imperfections; D Select—lowest in finishing grades—good for all-round projects. "Board" grades range from No. 1 (with small, solid knots), through No. 5—the poorest quality, suitable only for crating.

For most panel and case framing, and general all-round exhibit use, the "D" finishing grade, No. 1 board or No. 2 board grades, are the most practical.

Lumber Sizes

The beginning carpenter may feel she is being cheated when she orders and pays for a 1 x 4 and finds, when she gets it home, that the board actually measures about ¾-inch thick and 3⅝-inches wide. It is a common misunderstanding. The finished stock one buys at the lumber yard is referred to in its "nominal" size—its original, rough-sawed condition. Drying and preparing the board from rough-sawed to the finished, planed condition yields the final smooth material. The chart on page 114 shows the nominal, i.e. rough-sawed, size—the size you order—and the actual size of the finished board.

Lumber yards stock boards in standard lengths, usually starting at eight feet long and increasing by two-foot lengths. It is usually less expensive, if you need a seven-foot board, to buy the eight-foot length and trim it yourself. You would probably have to pay the eight-foot length anyway, and might be charged a cutting fee.

Lumber Sizes	
NOMINAL	**ACTUAL**
1 x 2	3/4 x 1 5/8
2 x 2	1 5/8 x 1 5/8
1 x 3	3/4 x 2 5/8
2 x 3	1 5/8 x 2 5/8
1 x 4	3/4 x 3 5/8
2 x 4	1 5/8 x 3 5/8
1 x 6	3/4 x 5 5/8
1 x 8	3/4 x 7 1/2
1 x 10	3/4 x 9 1/2
1 x 12	3/4 x 11 1/2

Do not assume, because you have ordered eight-foot lengths, that all boards will be a *true* length. Many boards will be at least ¼-inch longer. A few (out of a large order) may be ⅛-inch shorter. **Never assume** board ends are square. Whenever you are building framing for a panel *always* check the ends with the combination square.

The best way to buy lumber is to *go to the yard* and *to check the boards* as the lumberman pulls them from stock. You have the right to reject any boards that seem warped (do not buy *any* that are twisted like a propeller!), have too many knots, or have loose knots which may work out as the lumber is used.

PANEL MATERIALS

Standard 4-foot by 8-foot sheets of building materials, unlike board sizes, can be depended upon (as a rule) to be the full 4 x 8 size.

AD interior grade fir plyboard is the most commonly used material for panels, cases, case furniture, and lighting fixture enclosures. The ¼-inch thickness is strong enough for cases displaying small, lightweight objects; the ⅜-inch thickness is better for all-round use. Half-inch and ¾-inch sheets are used for case bases and platform construction.

Particle board is made from sawdust and chips mixed with resin and formed into 4 x 8 sheets. It is less expensive than plyboard, but will not hold screws as well and is heavier by far, than plyboard.

Hardboard (such as Masonite) is also used for panel construction. It is made in 1/8-inch, 3/16-inch, and 1/4-inch thicknesses. Both tempered (for exterior use) and untempered (softer) are available. It is difficult to pound nails into any hardboard; screws are more practical to use.

Upson board, made in a wide range of thicknesses and interior or exterior grades, is one of the most versatile and least expensive display materials. Most lumber yards stock sizes four-feet wide, six, eight, and twelve-feet long. The one-eighth-inch thickness, called Easy Curve, permits making background panels with curved surfaces (which are supported by pine and plyboard framing) and is so flexible it can be made into a 12-inch diameter cylinder. Panels may be made of the 3/16-inch thickness framed with 1 x 2 lumber and suspended in place by being bolted to 2 x 3s wedged between ceiling and floor with spring-loaded caps.

Other sheet materials include Homosote and Cellotex—both primarily insulating boards; and Fome-Core—an extremely light weight sheet of expanded plastic (similar to Styrofoam) backed on both sides with Kraft paper (similar to brown wrapping paper). It comes in 3/16-inch, 1/4-inch, and 1/2-inch thicknesses in 4 x 8 sheets. It is cut best with a sharp knife or an extremely fine saw blade. It is an excellent material for large cutouts.

Corrugated cardboard is also used—often to achieve a textural effect—in case backgrounds and to form the sides of curved case furniture (where support is provided by hidden boards). Colors of decorative display corrugated cardboards will fade quickly and should not be considered permanent. The cardboard should be painted for any long-term exhibit.

ADHESIVES

Liquid white (polyvinyl resin) glue, most often packaged in plastic squeeze bottles, is a good, all-purpose adhesive. It is used in wood joints (both framing and panel-to-frame) and for gluing 3-D letters for labels. The white color turns translucent as the glue dries.

Other white glues are casein-based, excellent for most purposes, but not waterproof and may be affected by humidity and/or high temperature. Check the label to determine if the white glue has a liquid resin or casein base.

Urea resin glue (Weldwood is one trade name) comes as a powder. Four parts of the powder are mixed with one part cold water to make a heavy paste. More water is added until the mix is about as thick as heavy cream. It is a good idea to let the mix stand about half an hour before using, but then must be used within four hours. Mix only as needed. Joints must fit tightly.

Epoxy, a two-part glue, will handle most spot-gluing jobs (mineral specimens, dinosaur repairs). It is a *very permament* kind of glue. Expense limits its use in museum situations.

Beeswax may be melted and mixed with a small amount of turpentine to form a soft, sticky, malleable ball for anchoring stone artifacts and other small objects to sloping panels.

FASTENERS

Framing, panels, cases, and case furniture are held together by glue and by nails, screws, or bolts. Joints may be strengthened by the use of metal braces.

 flat corner

 angle corner

 flat "mending" plates

 Tee braces

Nails most often used in exhibit construction are box and finishing nails (for framing, panel, case, and case furniture construction) wire nails and brads (for lightweight work—label fastening, etc.). Box nails are thinner than common nails and less apt to split wood. Wire nails (as cigar-box nails) are small nails one-inch or shorter, with a head; brads are nails one-inch long or shorter, with no heads (as finishing nails).

Nails are measured by penny size. To find the correct penny size, measure the length of the nail, subtract ½-inch and multiply by four. Thus, a 2½-inch long nail is an 8 penny nail—written "8d."

To decide what length of nail to use, choose one about three times as long as the board being nailed.

Actual size drawings: Box and Finishing Nails

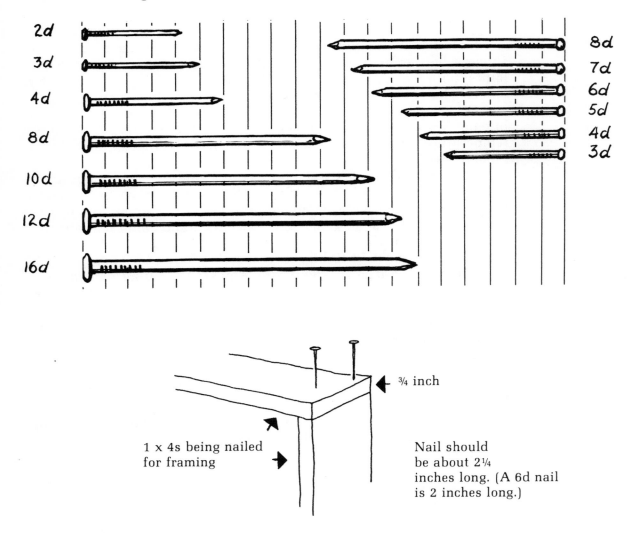

¾ inch

1 x 4s being nailed for framing

Nail should be about 2¼ inches long. (A 6d nail is 2 inches long.)

Cement coated nails (dipped in resin or shellac) are very strong fasteners and almost impossible to draw out. They may be used where framing will not show, to increase the strength of glued-and-nailed joints.

Commonly Used Flathead Wood Screws

Screws provide greater holding power than nails and have the additional advantage of pulling pieces together. They should be used wherever more strength is required. The list below shows minimum sizes of flathead screws recommended for fastening plyboard sheets to a supporting frame. Longer screws should be used when possible.

Plyboard	Screw
1/4 inch	#4, 3/4 inch long
3/8 inch	#6, 1 inch
1/2 inch	#6, 1 1/4 inch
5/8 inch	#8, 1 1/4 inch
3/4 inch	#8, 1 1/2 inch

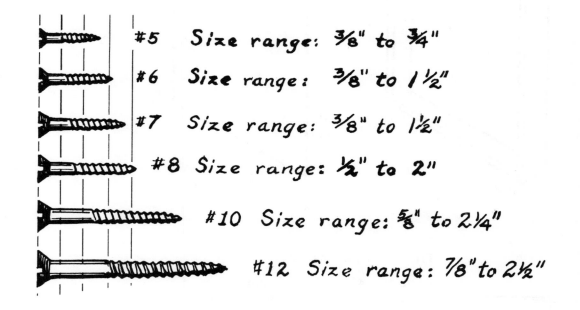

#5 Size range: 3/8" to 3/4"

#6 Size range: 3/8" to 1 1/2"

#7 Size range: 3/8" to 1 1/2"

#8 Size range: 1/2" to 2"

#10 Size range: 5/8" to 2 1/4"

#12 Size range: 7/8" to 2 1/2"

Bolts and nuts are used in building exhibits which will be taken down and stored. Very handy devices, often used in furniture manufacture, are Tee-nuts which can be driven into a pre-drilled hole in wood to provide metal threads for bolts. They are useful particularly where it will be difficult to hold a regular nut for tightening. The prongs of the Tee-nut are pulled into the wood as the bolt is tightened, keeping the nut from turning and preventing it from falling out when the bolt is removed. Sizes are: 8-32, 10-24, 1/4-20 (most common, and used with either a 1/4-inch 20 thread stove or machine bolt), 5/16-18, and 3/8-16.

PANEL CONSTRUCTION:

4' x 8' Panel
(Panels used to create built-in wall.)

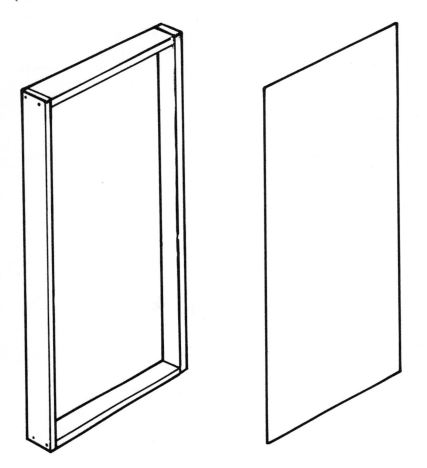

Framing requirements:

 2 1" x 4" x 8' B grade pine
 2 1" x 4" x 3'10 1/2" B grade pine

Panel requirement:

 1 3/8" x 4' x 8' AD plyboard

Use white liquid resin glue, 8d coated box nails for framing; 4d finishing nails to fasten panel to frame.

Procedure:

Glue and nail frame together. Spread glue on frame; place panel on frame; line up panel with frame along *one* eight-foot side. Don't worry if rest of frame is out of line. Use finishing nails and fasten panel to frame along the one eight-foot side. After nailing down one long side, push frame into place on other sides, lining up with panel. Complete nailing panel to frame, using finishing nails.

118

8' x 8' Panel

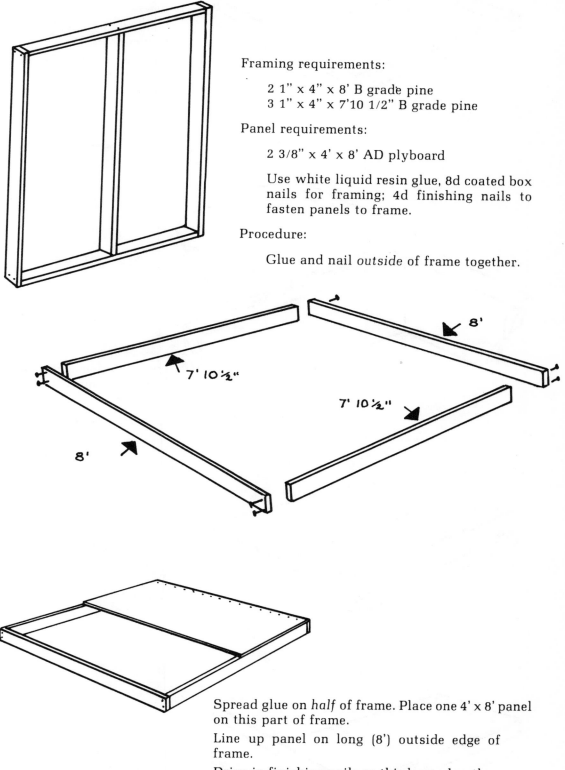

Framing requirements:

 2 1" x 4" x 8' B grade pine
 3 1" x 4" x 7'10 1/2" B grade pine

Panel requirements:

 2 3/8" x 4' x 8' AD plyboard

Use white liquid resin glue, 8d coated box nails for framing; 4d finishing nails to fasten panels to frame.

Procedure:

Glue and nail *outside* of frame together.

Spread glue on *half* of frame. Place one 4' x 8' panel on this part of frame.

Line up panel on long (8') outside edge of frame.

Drive in finishing nails on this long edge, then push frame into line and nail panel to frame on top and bottom.

119

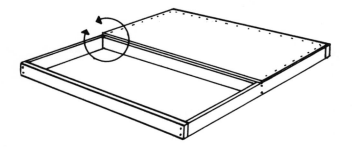

Glue and nail center *framing member* in place.

Be sure it extends only half of its thickness under top panel. (See detail below.)

Spread glue on center framing member under top panel. Nail panel to center framing member.

Spread glue on remaining half of framing.

Put second panel in place, butting up against first panel as tightly as possible.

Nail second panel to *center* framing member *first*, then line up rest of frame with panel and finish nailing panel to frame.

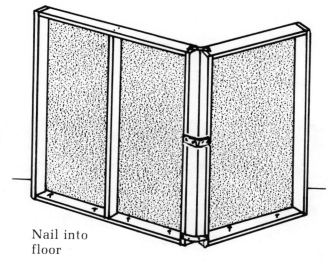

Nail into
floor

BACK VIEW

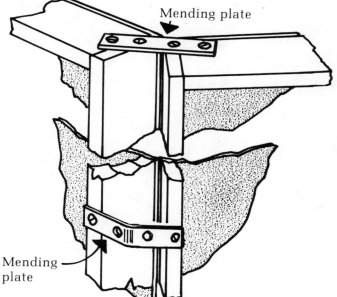

Mending plate

Mending
plate

Placing Frames in Position

6" mending plate screwed to top.

Nails driving through bottom framing member into floor.

Nails should be driven to within 1/2" of head so they may be removed if a change in wall direction is desired.

Wall must not extend more than 12' in a straight line. Panels *must angle* to make wall rigid and strong.

If panels cannot be nailed to floor, use mending plates across back of frames. Mending plate may be bent to desired angle by placing in vise, then bending with pliers.

One end of panel wall should be fastened to room wall. Use 6" angle corner brade. Additional rigidity may be secured by fastening 1 x 4 brace from top of panel framing to room wall.

Angle brace

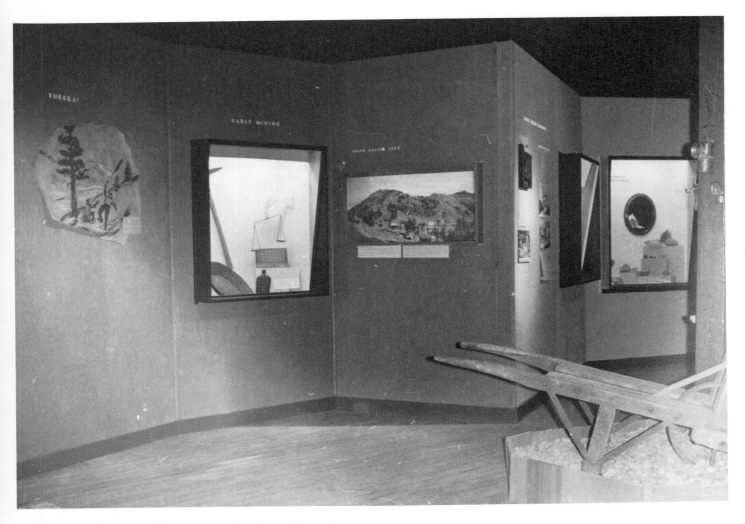

Red Men Hall Museum, Empire, Colorado

As exhibit materials become available and as funds are obtained for additional building materials, openings may be cut into panels and cases built behind them. Until such time, panels may be used to display photographs, drawings, maps, prints, graphs, etc. This permits great flexibility in designing a room installation.

CASE CONSTRUCTION (for panel wall)

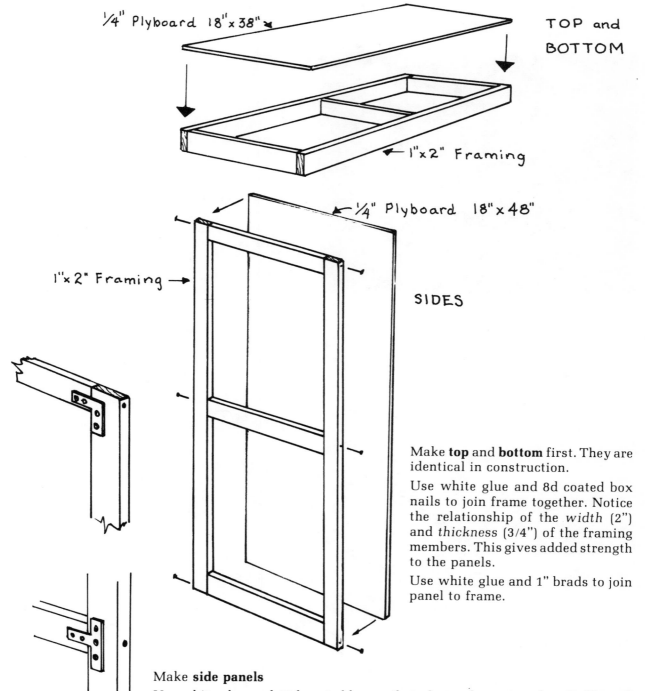

¼" Plyboard 18"×38"

TOP and BOTTOM

1"×2" Framing

¼" Plyboard 18"×48"

SIDES

1"×2" Framing

Make **top** and **bottom** first. They are identical in construction.

Use white glue and 8d coated box nails to join frame together. Notice the relationship of the *width* (2") and *thickness* (3/4") of the framing members. This gives added strength to the panels.

Use white glue and 1" brads to join panel to frame.

Make **side panels**

Use white glue and 16d coated box nails to fasten frame together. Drill 9/64" pilot holes through the uprights *but not into the cross braces* and use just one nail at each joint. This will hold the pieces in place until metal braces are added. *Notice the different position of the framing members* from that of the top and bottom sections. Reinforce the four corner joints with 3" flat corner braces; reinforce the center piece with two flat 3" Tee braces (one at each end) being careful to place the metal braces so the screws will not run into the nails.

Use white glue and 1" brads to join side panels to framing.

123

ASSEMBLY OF CASE

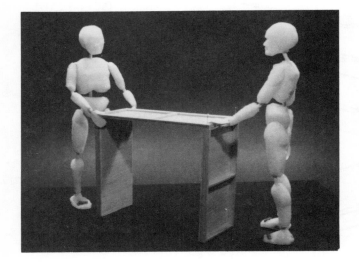

Finish in one day so glue does not set completely until case is put together and square.

Fastening sides to top and bottom:

Have someone help hold pieces in place; **top** and **bottom** resting on end, with panel surfaces facing; one side piece is fastened to top and bottom with white glue and two 10d coated box nails (1).

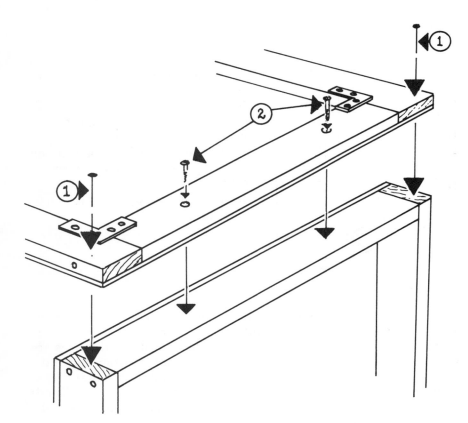

Use a countersink drill to make holes for two #10 flathead wood screws 1 1/2" long (2).

Repeat steps for other side.

Lay open frame "box" down on floor with front side down.

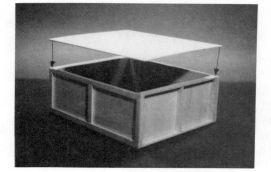

Fasten **back panel** to case box with white glue and 3d coated box nails. Be *sure* panel is cut *square* at all corners. Nail panel down along one long edge spacing nails at about 6" intervals, then pull case box into correct alignment and put a nail in the center of each of the other three sides to hold case in line.

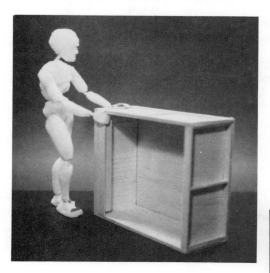

Add wired and mounted 3-foot fluorescent fixture to top of case. Use white glue and 10d coated box nails, driving nails through sides into fixture-mounting board which is set in flush with front of case box.

Side leg units are made of 2 x 2 pine, 31" long, with 13"-long cross-braces and 5"-long vertical cleats (for attachment to case box). These units are fastened together with two 2 x 2 pine rails about 40" long (check outside measurement of case box). Make all joints with white glue and 6d coated box nails.

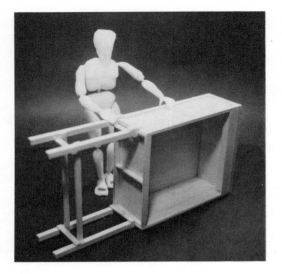

With case box resting on its side, attach completed leg units. Line up legs flush with *back edge* of case box so that the box overhangs the front legs by at least 4". This is to permit the case front to be pulled up snug to panel. Attach legs to box with white glue and #8 flathead wood screws 1 1/4" long.

Drill 3/8" hole in bottom center of each leg and insert stem of 2" caster.

Preparing panel for case exhibit:

Mark off a three-foot square opening, bottom edge to be 36" from floor. Use carpenter's level to be sure window opening is level with floor. Use framing square with level to be sure corners of opening are square. Drill holes through the panel *from front to back* (to avoid splitting wood from front surface) in each corner, using a 3/8" spade bit with the electric drill. Use a saber saw to cut out the 3' x 3' opening.

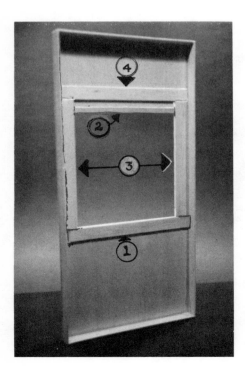

1. Reinforce back of panel with one 1 x 4 pine board extending full width, inside vertical framing and flush on top edge with bottom of window opening.
2. Reinforce top of window opening with 1 x 2 pine 36" long, flush with top edge of window opening.
3. Reinforce sides of window opening with 1 x 4 pine 3' 4" long, set in flush with window opening.
4. Place 1 x 4 brace 3' 10½" long across top of vertical window braces.

Use white glue and #7 flathead wood screws ¾" long on all panel braces.

Shadow box frame is made of 1 x 10 pine; top and bottom boards are 35 7/8" long, sides are 34 3/8" long.

Top and bottom pieces overlap sides.

The pieces are cut 1/8" shorter than window dimensions to make it easier to insert frame in opening.

Use white glue and 8d finishing nails to construct frame.

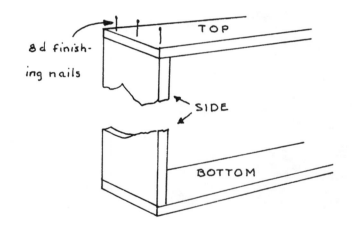

Insert frame in reinforced, rough-cut window opening. Line up back of frame flush with back edge of reinforcing braces.

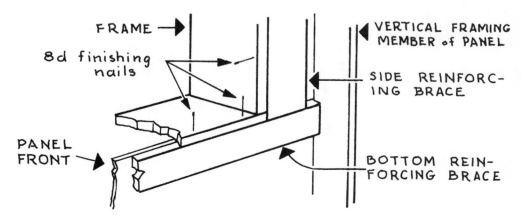

Use white glue and 8d finishing nails to fasten frame in place driving nails through bottom piece of frame into bottom reinforcing brace. Use framing or combination square to check corners for accuracy before using glue and nails to fasten remaining sides. *Be very careful* to install frame so that corners are *square*. An off-square frame will make glass installation very difficult.

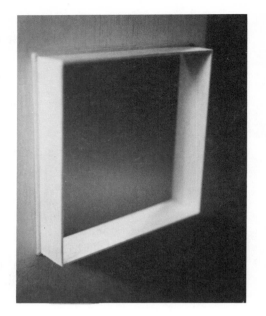

Use 3/4" quarter-round or base shoe molding to trim between shadow-box frame and panel front. Attach with white glue and 1" brads; set nails 1/16" below surface; fill with spackling paste. The molding will hide the rough-cut opening.

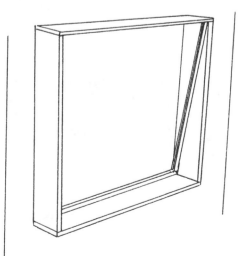

Quarter-round back glass stop

7/32" Crystal weight glass

Quarter-round front glass stop

Use 1 1/2" brads to attach strips of quarter-round for glass stops. Install back stops first, bottom strip flush with *back edge* of frame. Side stops hold glass on slant from top to bottom.

Use 7/32" crystal weight glass. Have it cut 1/4" shorter than inside dimensions of frame in both length and width. It will be easier to tip into place (put bottom edge in first) and the thickness of the molding strips will hide any gaps.

Fastening case to panel:

Roll case into position behind panel. Put heavy-duty screw-eye in back edge of panel framing (even with middle brace of side of case).

Put screen-door hook in back vertical brace of side of case, even with middle brace.

Fasten turnbuckle to screw-eye in panel using a length of bailing wire.

Screen-door hook is slipped through eye of turnbuckle and case is drawn up tight to panel by tightening turnbuckle.

It is a good idea to glue a continuous strip of foam-rubber weatherstripping all around the front edge of the case (where the case contacts the panel) to help keep dust from entering the case.

Panel Wall and Cases

Red Men Hall Museum, Empire, Colorado

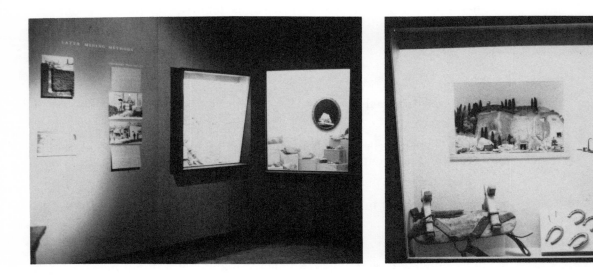

Diorama opening cut in back of case;
associated materials exhibited in case.

Behind the Scenes

Exhibit case behind panel wall;
diorama fastened directly to case.

Turnbuckles loosened, screen-door
hooks unfastened, and case pulled
away from panel. *(More recent
design installs light directly in
case.)*

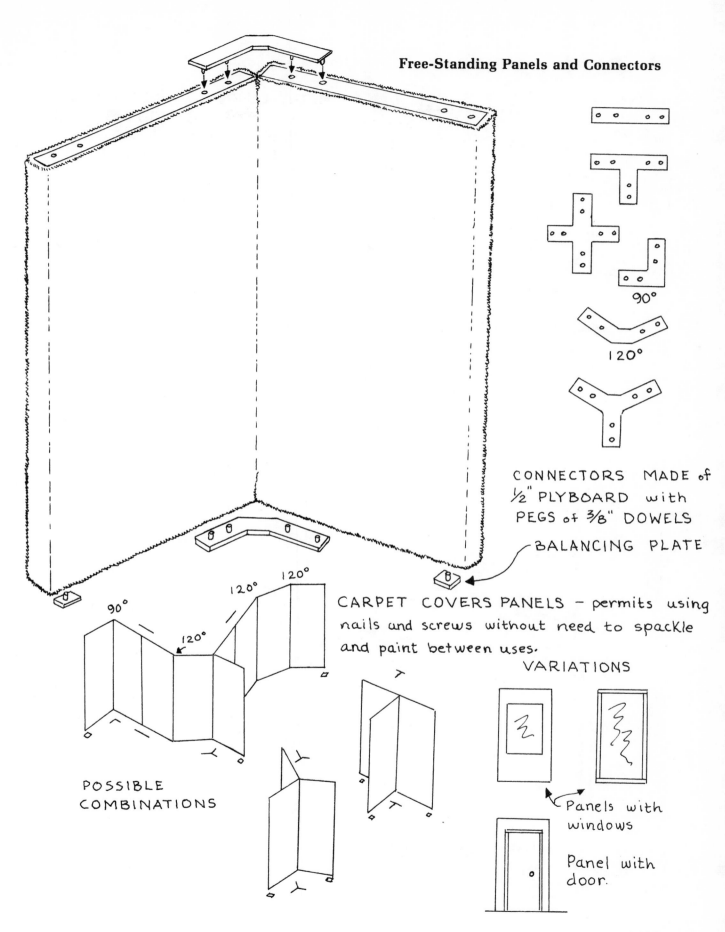

CONNECTORS MADE of
½" PLYBOARD with
PEGS of ⅜" DOWELS

BALANCING PLATE

CARPET COVERS PANELS — permits using
nails and screws without need to spackle
and paint between uses.

90°

120°

120°

120°

POSSIBLE
COMBINATIONS

VARIATIONS

Panels with
windows

Panel with
door.

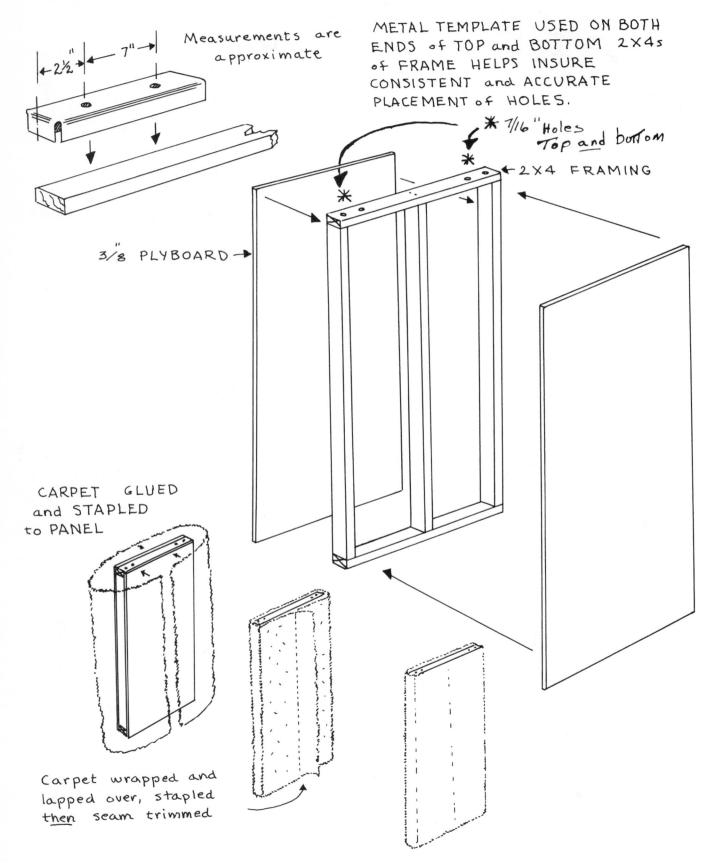

Measurements are approximate

METAL TEMPLATE USED ON BOTH ENDS of TOP and BOTTOM 2X4s of FRAME HELPS INSURE CONSISTENT and ACCURATE PLACEMENT of HOLES.

2½" 7"

* 7/16" Holes Top and bottom

* 2X4 FRAMING

3/8" PLYBOARD

CARPET GLUED and STAPLED to PANEL

Carpet wrapped and lapped over, stapled then seam trimmed

132

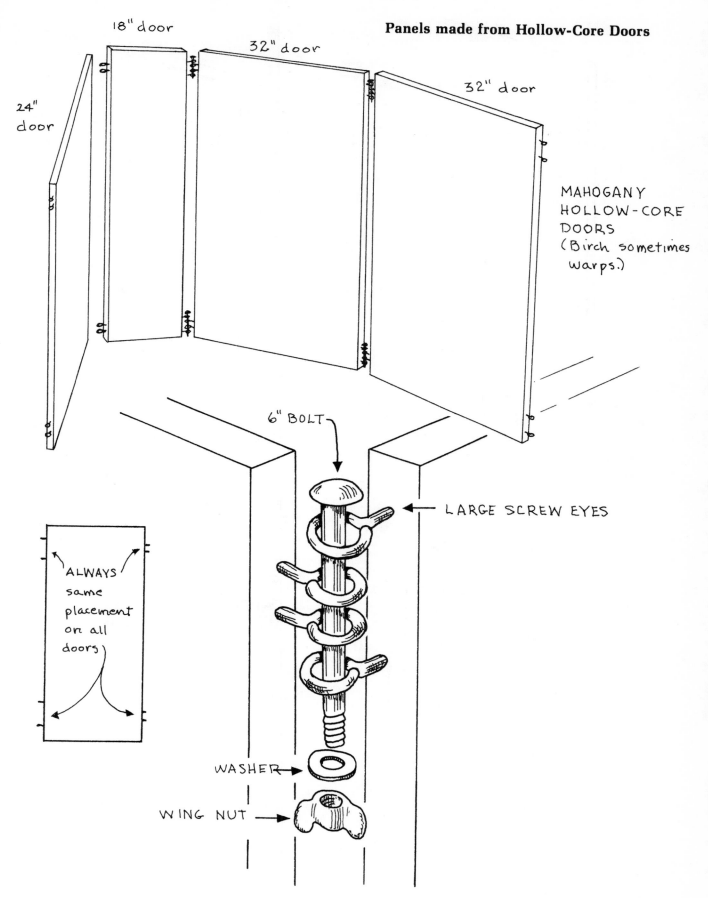

18" door

32" door

32" door

24" door

MAHOGANY
HOLLOW-CORE
DOORS
(Birch sometimes
warps.)

6" BOLT

LARGE SCREW EYES

ALWAYS same placement on all doors.

WASHER

WING NUT

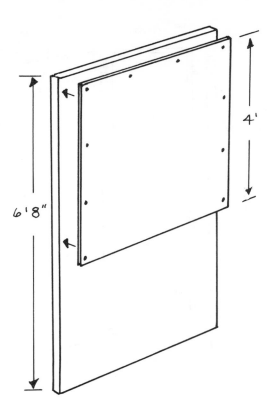

4'

6'8"

HOLLOW-CORE DOORS are made of ⅛" thick "skins" of plyboard glued to a frame made of 2×2s. Reinforcing blocks are glued where doorknobs are usually placed.

The ⅛" "skin" on each side of the door is too thin to hold nails or screws.

A plyboard panel may be screwed to the 2×2 frame to provide solid attachment for specimens or plexiglas boxes.

CARPET can be glued to the plyboard panel.

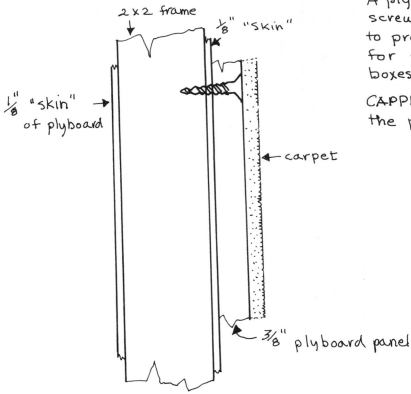

2×2 frame

⅛" "skin"

⅛" "skin" of plyboard

carpet

⅜" plyboard panel

Leave masking paper on both sides of all pieces to protect plastic surface.

Making a Plexiglas Cube

Use 1/4" Plexiglas. Cut four side pieces the same size. **Note drawing** showing all edges lapping in same direction. Cut top piece to lap all sides.

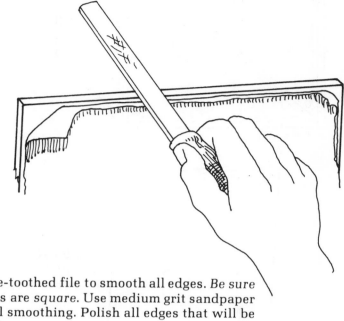

Use fine-toothed file to smooth all edges. *Be sure all edges are* square. Use medium grit sandpaper for final smoothing. Polish all edges that will be exposed.

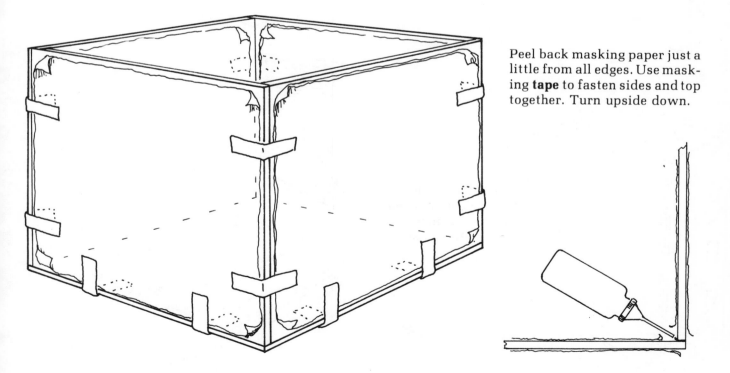

Peel back masking paper just a little from all edges. Use masking **tape** to fasten sides and top together. Turn upside down.

Use Plexiglas solvent and applicator or brush, run solvent *all* around *inside* of joint of top and sides.

135

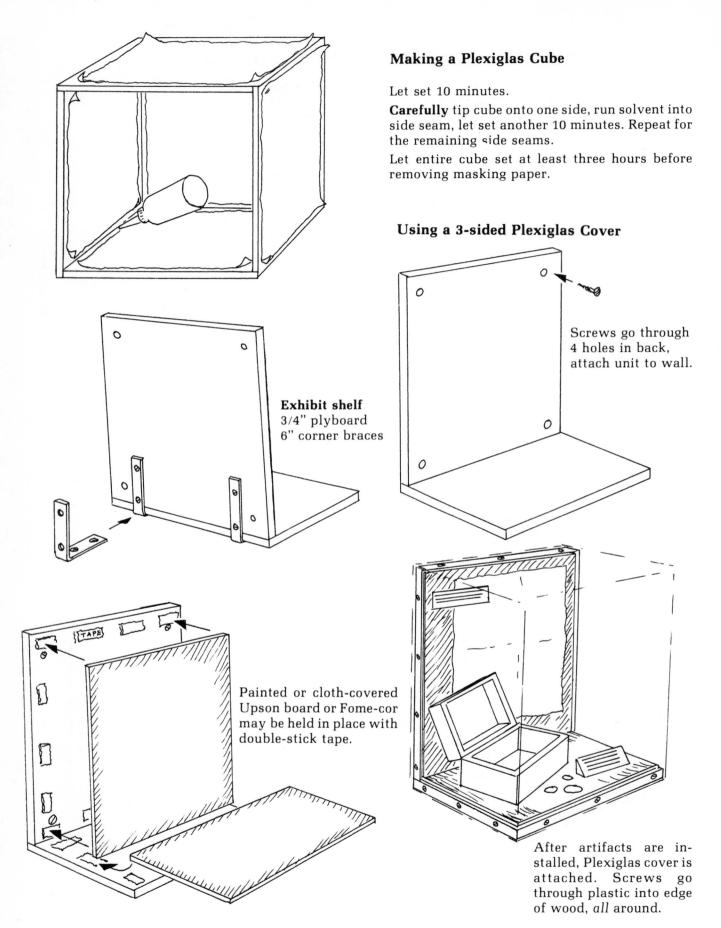

Making a Plexiglas Cube

Let set 10 minutes.

Carefully tip cube onto one side, run solvent into side seam, let set another 10 minutes. Repeat for the remaining side seams.

Let entire cube set at least three hours before removing masking paper.

Using a 3-sided Plexiglas Cover

Screws go through 4 holes in back, attach unit to wall.

Exhibit shelf
3/4" plyboard
6" corner braces

Painted or cloth-covered Upson board or Fome-cor may be held in place with double-stick tape.

After artifacts are installed, Plexiglas cover is attached. Screws go through plastic into edge of wood, *all* around.

Wiring and Installing
a Fluorescent Light Fixture

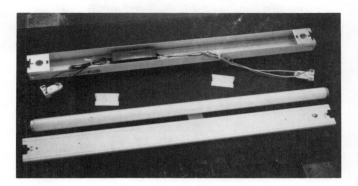

Disassembled fixture (as shipped)

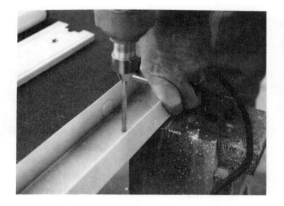

Drill 1/4" holes for mounting bolts (if needed).

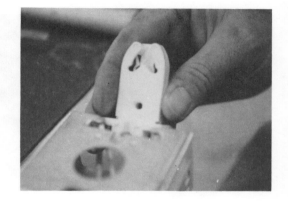

Socket is snapped in place and

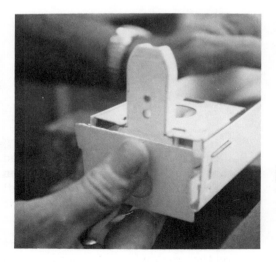

fixture end pushed in place.

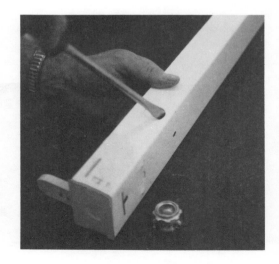

After deciding from which end cord is to run, remove knock-out plug.

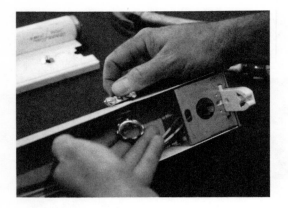

Install Romex connector in hole. (This protects cord from chafing against metal edge and helps to keep wire from pulling out.)

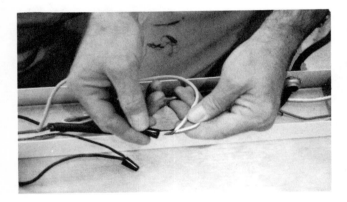

Use 14 gauge SJO 3-wire (grounded) cord. The three wires will be colored black, white, and green.

In the fixture there may be several colors of wires. Use *only* the black and white being *sure* to join the black wire of the cord to the black wire of the fixture, and the same with the white.

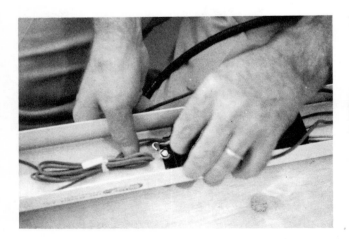

Ballasts in some fixtures are equipped with a short wire, about 3/4" long, on one end to which the green (ground) wire may be attached, using a plastic wire connector (wire nut).

If the ballast does not have a grounding wire, the green wire of the cord may be attached to the mounting bolts which hold the ballast in place.

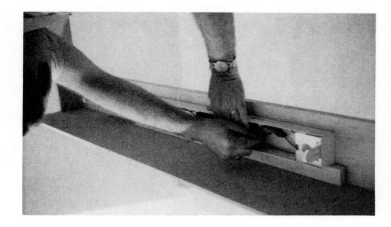

Use fixture for guide when marking location of bolt holes to be drilled through mounting board. Use a 1 1/2"-wide scrap board as a spacer to be sure top of fixture will be down 1 1/2" from top of case.

Drill holes through mounting board and countersink on front side of wood (to permit flush fit of 3"-long 1/4" flathead bolts which are used to fasten fixture to board.

Push bolts through mounting board from front side. If working alone, hold bolts in place with strips of masking tape.

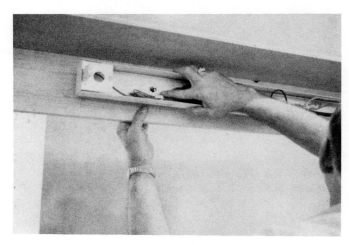

Hang 1/2" x 1 1/2" pipe nipples over bolts on inside of case to serve as spacers to hold fixture a safe distance from board (overheated ballasts may sometimes cause fires).

Hang fixture on bolts, add nuts and tighten.

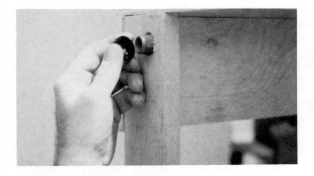

Drill 7/8" hole through end of wood case through which cord will run and insert 1/2" x 1 1/2" pipe nipple attaching with threaded plastic grommets on each end. This protects the cord from rough edges of wood. Pull free end of cord from fixture through pipe nipple to outside of case.

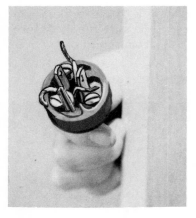

Use rubber 3-wire cap for grounding type receptacles.

The plug will have three screws: brass, silver, and a hexagonal green screw.

Be sure to attach the green wire of the cord to the green screw of the plug; the black wire to the brass screw, and the white wire to the silver.

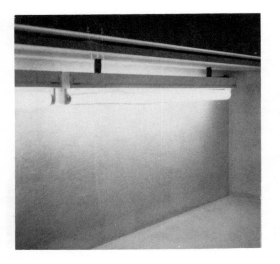

Two single-tube, 3-foot fluorescent lights mounted in a 7-foot case.

Case History of a Case

Four pieces of 1/2" thick plyboard temporarily are tacked together with 4d nails.

A pattern curve made from a folded length of wrapping paper (folded to make a symetrical curve) is traced on the boards.

The boards are cut with electric saber saw.

Two pieces of curve are used for ends; two are fastened together with glue and 4d coated box nails (clinched over on ends) to form a 1"-thick center section.

These sections are joined by 1 x 4s attached with glue and 4d coated box nails.

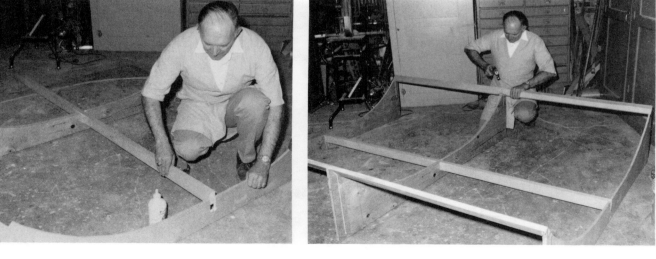

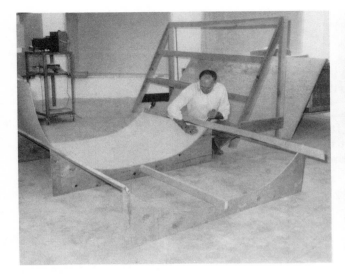

Easy-Curve Upson Board is fitted to frame and trimmed, but not fastened.

Frame is installed in case then Upson board is added.

Joints are sealed with tape and paste.

All pieces are checked for fit before final painting and modeling are done.

CONSTRUCTION OF CASE FURNITURE WITH CURVED SIDES

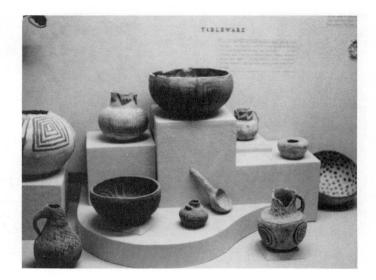

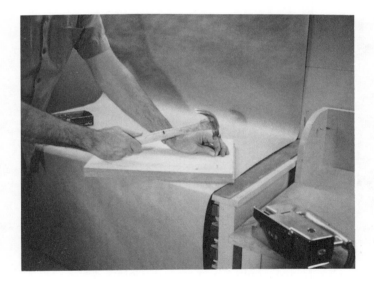

Two pieces of Cellotex temporarily are joined together with nails. Nails are put through scrap area of pieces.

Bottom left: Saber saw is used to cut through both pieces at once along the curve.

Bottom right: White glue and 3d finishing nails are used to fasten the bottom piece of Cellotex to lengths of scrap lumber.

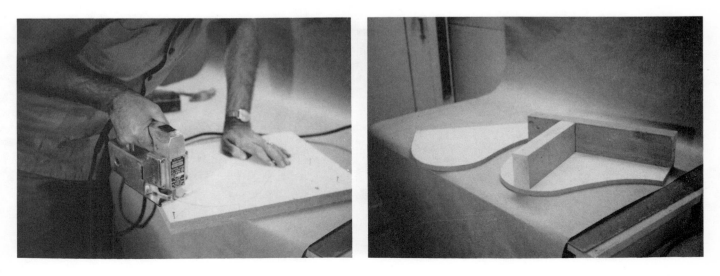

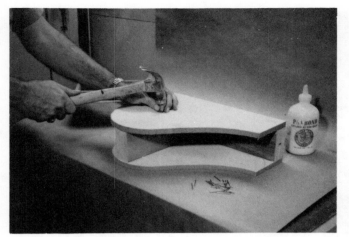

White glue and 3d finishing nails are used to fasten top piece of Cellotex in place. Nails are set just below surface and holes filled with spackling paste.

White glue and straight pins hold a strip of corrugated cardboard in place. Cardboard may be applied with corrugations exposed (as here) or with smooth side out. Weight of displayed object is supported by interior pieces of wood.

When glue has set, pins are removed and cardboard is trimmed with sharp X-Acto knife.

Cardboard should be painted. Colors of decorative corrugated cardboard will fade.

Labels

VITAL STATISTICS

Most adults read at the rate of about 250 to 300 hundred words per minute.

Readers prefer short sentences—an average of 18 to 20 words.

The average viewing time for most exhibits is no more than *forty-five seconds.*

> Thus, a visitor reading at a rate of 300 words per minute will average about 5 words per second, or 225 words for the full 45-second attention span.
>
> This allows no time for seeing the objects in the exhibit.

Recommended word count for labels is between 75 to 100 words.

Using all caps in a label may reduce the speed of reading by almost 14 percent over the same label printed in caps and lower case.

Recommended sizes of type:

> Nothing smaller than 24-point for general text. Label typewriters usually print 1/4 inch high letters—close to the 24-point size.
>
> Where space permits, 30-point will be better.

Line length should not go over 65 to 70 characters (letters). Space between words and sentences should be counted as a letter.

Enough space (at least the height of a capital letter) should be designed between the bottom of a line of text and the top of a capital letter on the following line.

An extra space between paragraphs will help the visitor/reader to scan/read label information.

Labels should be written to give **immediate**, first; **secondary**, then **detailed** information and the design in terms of point size should reflect this **descending** priority of information.

Most labels will look better on paper painted to match the color of the case or panel on which they are placed. (See page 135 in *Exhibits for the Small Museum*, published by AASLH.)

TYPED LABELS

Many museums seem to use the Orator typing element on an IBM Selectric typewriter for labels. The idea seems to be that bigger is better—easier to read. But psychologists who have studied reading patterns have found that the use of all caps in a body of text reduces the ease and speed of reading.

THE ORATOR ELEMENT HAS LETTERS THAT ARE LARGER
AND ARE USED AS "CAPS", BUT THE <u>DESIGN</u> OF ALL
LETTERS IS THAT OF CAPS.

A better element to use is this LETTER GOTHIC
which has both caps and lower case.

Typed labels may be taken to a local copy/print shop that has a copier that will enlarge originals. Often, these copiers will accept colored paper used for your labels. The enlarged copy may be used as an original to produce yet a larger copy of the label. Examples are shown here:

Original:

PEOPLE of the PLAINS obtained horses from the Spanish
settlements in the 1800s and became nomadic hunters.
Living in skin tents (tipis), they moved camp often
to follow the hers of bison. Often they used glass
beads obtained from European traders to decorate
skin clothing that was used for special occasions.

First enlargement:

PEOPLE of the PLAINS obtained horses from the Spanish
settlements in the 1800s and became nomadic hunters.
Living in skin tents (tipis), they moved camp often
to follow the herds of bison. Often they used glass
beads obtained from European traders to decorate
skin clothing that was used for special occasions.

First enlargement then used as original, copied again to produce this next size up:

PEOPLE of the PLAINS obtained horses from the Spanish
settlements in the 1800s and became nomadic hunters.
Living in skin tents (tipis), they moved camp often
to follow the herds of bison. Often they used glass
beads obtained from European traders to decorate
skin clothing that was used for special occasions.

DRY MOUNTING LABELS TO SUPPORTING CARDBOARD

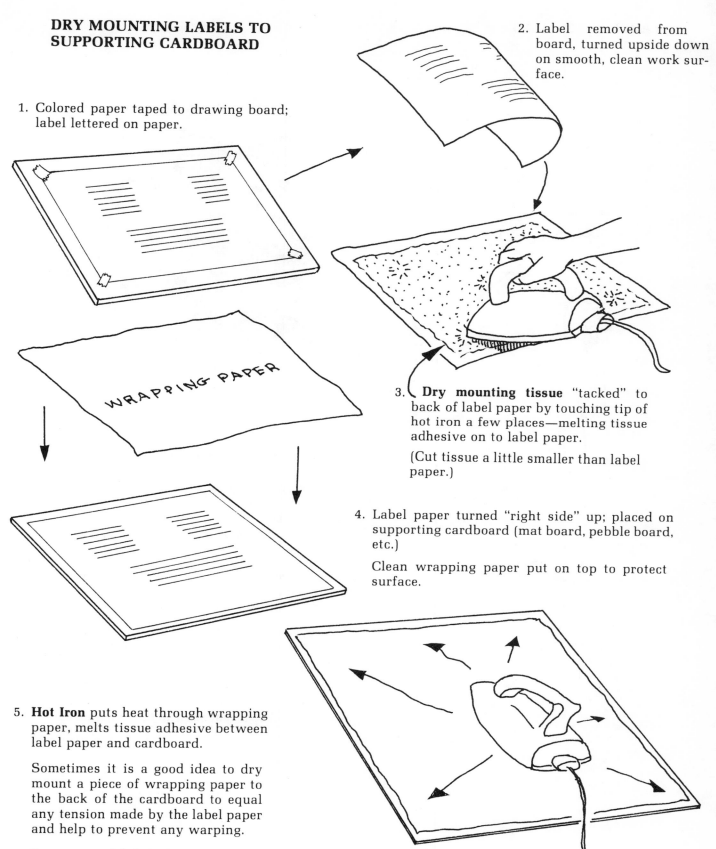

1. Colored paper taped to drawing board; label lettered on paper.

2. Label removed from board, turned upside down on smooth, clean work surface.

3. **Dry mounting tissue** "tacked" to back of label paper by touching tip of hot iron a few places—melting tissue adhesive on to label paper.

 (Cut tissue a little smaller than label paper.)

4. Label paper turned "right side" up; placed on supporting cardboard (mat board, pebble board, etc.)

 Clean wrapping paper put on top to protect surface.

5. **Hot Iron** puts heat through wrapping paper, melts tissue adhesive between label paper and cardboard.

 Sometimes it is a good idea to dry mount a piece of wrapping paper to the back of the cardboard to equal any tension made by the label paper and help to prevent any warping.

6. Dry-mounted label **then** trimmed to final size.

 (Dry mounting tissue may be purchased at most photo supply stores.)

LABEL PLACEMENT

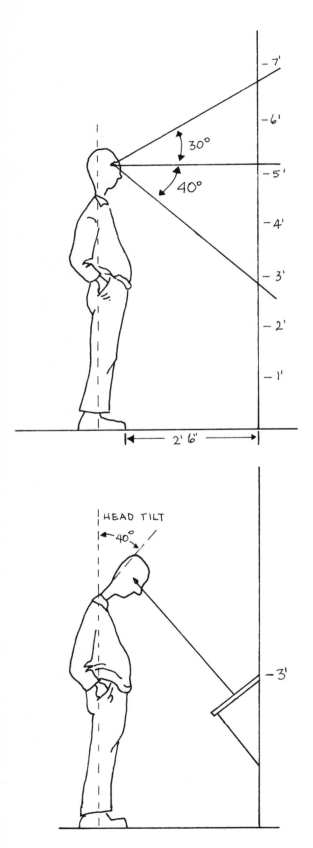

Unless invited to touch objects, most American adults will stand about an arm's length or a little more, away from the objects. (Edward T. Hall calls this the "far phase" of "personal distance" in *The Hidden Dimension*.)

This "personal distance" is from two-and-one-half to four feet.

Our eyes see as if they were at the peak of an approximate 60-degree angle cone (30-degrees above; 40-degrees below our eye level.)

We see most easily those things that are at a right angle to our *direct* line of sight. **Thus:**

> Labels will communicate best when they are no more than about one foot *above* eye level nor no more than three feet *below*, and if they are placed at a right angle to the probable line of sight.

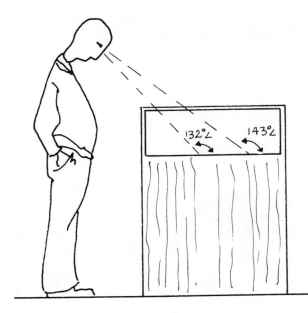

Open books, documents, papers, drawings, photos, etc. are hard to see when they are flat in the bottom of a library-type of case.

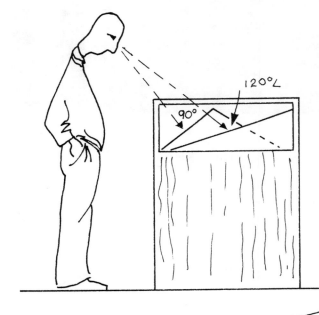

Simple wedge-shaped case furniture brings these flat objects closer to a right angle with the line of sight, making them easier to see.

Observation Post on the Atlantic Coast at Fortress Louisbourg, Nova Scotia

Viewer sights along finder which rotates on a circular platform. Finder points to identification on platform. Notebook pages contain information about the surrounding countryside and seashore.

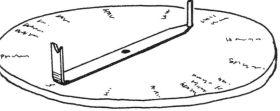

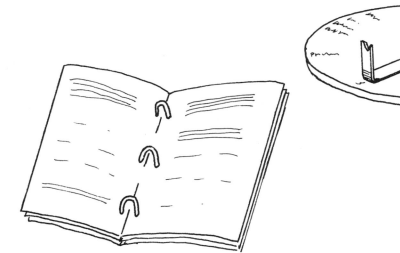

Notebook pages are sealed between two pieces of *clear* Contac plastic. (Leave at least 1/2" clear plastic margin around pages.)

Three U-bolts hold notebook pages to support made of 3/4" exterior grade plyboard.

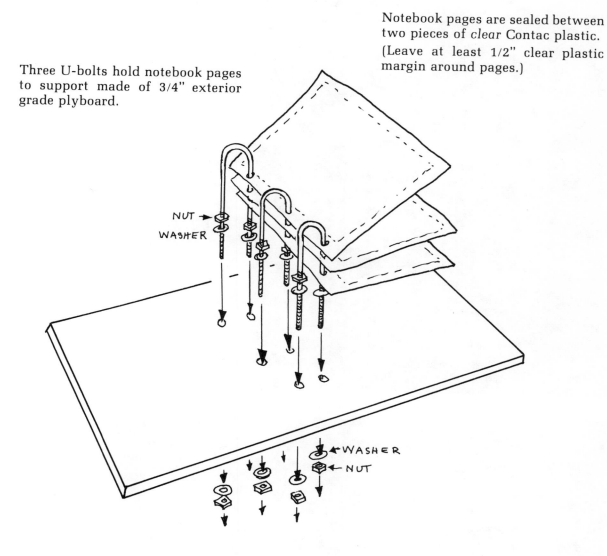

NUT →

WASHER

← WASHER

← NUT

Original Pages should be kept on file; photocopies used in notebook. This makes it easier to replace pages that become dirty and/or torn.

Labels printed on glass or on plastic are *very* hard to read!

AVOID THIS!

QUANTITY PRODUCTION OF PLASTER LETTERS

(Originally published by the American Association for State and Local History, Technical Leaflet 23)

Three-dimensional letters usually are used for the "headline" and "subhead" labels in a case. While commercially made letters are available it is relatively inexpensive to make 3-D letters. Latex molds are made over a pattern alphabet and as many letters as are needed are then cast with plaster.

Pattern alphabets may be found in lettering books and traced onto tracing paper or onion skin paper with a soft pencil. *Do not use carbon paper and deface the book!* To enlarge letters to a desired size follow the steps outlined below.

a. Original letter
b. Graph of squares drawn over original
c. Graph of same number of squares drawn to desired size.
d. Corresponding points (such as no. 1 and no. 2) are established and the enlarged letter sketched in.

a. b.

c. d.

A more accurate way is to ask a photographer friend to make a slide of the alphabet, then project it to the size needed. The alphabets chosen should not be smaller than 3/4" and should not have any parts that are extremely thin, as the final plaster letters probably will break.

Three alphabets are shown.

153

Roman upper and lower case and numerals.
Good for Colonial Period and Revolutionary War times.

Gothic upper case.

Gothic lower case and numerals.

154

Trace the pattern alphabet onto masonite or other hardboard material at least 1/4" thick. Drill holes through the enclosed parts of the letters, A, B, D, O, P, Q, and R. These holes should be large enough for the coping saw blade.

Below left: Letters drawn on 1/4" masonite, holes drilled. Scrap piece of wood with "V" cut is clamped to table and provides support for three sides of letter as it is cut. A power jig-saw makes the work easier.

Right: Run saw blade through a hole, fasten the blade in the saw and cut out the enclosed portion.

Upper and lower case of the Barnum family. Good for use in Civil War displays.

Running the saw blade through a hole and fastening the blade in the saw to cut out the enclosed portion will make it easier *before* cutting out the entire letter. Unfasten the blade from the saw and remove it from the hole. Replace blade in saw, then complete cutting out the letter.

Sand the letters smooth, rounding the edges. To fill the pores of the material, the letters are given a brush coat of shellac or a spray coat of clear lacquer from a pressure spray can. When they are completely dry they are sanded once more with very fine sandpaper. A light coat of paste floor wax is applied, permitted to dry, and polished with a soft cloth. The final patterns should be *very* smooth. They are placed on one large or several small pieces of scrap plate glass, as an extremely smooth base surface is needed. Sharp edges of scrap glass may be rounded with sandpaper. Wear protective goggles when sanding glass. A small paint brush is used with the latex. Wet the brush in water, then work up a lather with a mild soap (such as Ivory hand soap). Gently squeeze the excess lather from the brush, then dip into the latex and anchor the letters by flowing the latex around the edges of the letters where they rest on the glass.

As soon as the letters are anchored, give them a full brush coat of latex. *Watch out for bubbles!* Pop them by blowing on them or by pricking with a pin. Then be sure to wash the brush between each coat of latex. The pre-lathering will help in getting the brush clean. If something goes amiss, the dried latex may be removed from the brush by soaking the bristles in gasoline.

Let each coat of latex dry completely before adding the next. The color will change from milky white to a transluscent yellow as the rubber dries. Apply about eight coats to the letters. Do not try to fill up the enclosed holes of A, B, D, O, P, Q, and R, or the rubber will become so stiff that the plaster letters will be hard to remove without breaking.

After several coats of latex have been applied, a plaster-of-Paris supporting mold is made. Enclose the latex-covered letter with strips of wood (which have been waxed). Note that the placement permits using strips of random lengths. The strips are held in place with lumps of oil-base modeling clay and the inside corners of the "well" are also sealed with clay. Be sure the whole setup of glass, well, and letter is on a level surface. If the finished supporting mold does not hold the latex mold level, the cast plaster letter will be thick on one side and thin on the opposite, resembling a cake baked in a tilting oven. Measure enough water to fill the well at least half-way and pour into a plastic or enamelware mixing bowl. (Do not wash out the pans when the plaster has been used. Let the excess plaster dry, then run the pan full of cold water. The plaster will loosen from the enamelware pan or plastic bowl and may be lifted out in a piece.) Sift or shake plaster-of-Paris into the water until an island forms. Let the mound of plaster get completely wet, then sift a small additional amount into the water until it begins to form a second mound. Let this plaster absorb the water, stir *gently* to avoid creating air bubbles, then pour into the well. Vibrate the plaster by banging on the table top or by shaking the supporting glass surface. This will drive out trapped air. Let the plaster harden at least two hours. Let the excess plaster harden in the mixing bowl—to indicate when the mold is sufficiently hard.

Applying latex with small paint brush. This will anchor it to the glass.

Apply a full coat of latex to the letter after anchoring to glass.

Waxed wood frame encloses the latex-covered letter. Placement permits use of random-length strips held together with oil-base modeling clay.

Gang molds may be made so that it is possible to make several casts of one letter at one time.

When the plaster has set, remove the wooden strips, then take the supporting mold from the latex. The inner plaster surface will be powdery. Peel the rubber mold away from the pattern letter. Dust the inner surface with talc to keep the sides from sticking together.

Give the plaster supporting mold three or four coats of shellac or spray with clear lacquer to seal the surface, then apply a light coat of paste wax. This is to prevent the plaster used in casting the letters from building up and distorting the latex mold.

Place the latex mold in the supporting plaster mold and brush with a twenty-five percent solution of hydrochloric (muriatic) acid. Drain the mold. The acid will counteract the ammonia in the latex and will keep the cast plaster letters from being powdery. Apply this acid solution each time you cast a letter for at least the first ten letters. After enough casts have been made, the acid is no longer necessary.

Mix more plaster and spoon into the molds. Try not to pour in so much plaster that the molds run over. Vibrate to get out trapped air. Let the plaster set at least two hours, then remove the letters and trim, if necessary. They will be easier to trip when they are first removed from the mold.

After several letters of the same character have been cast and trimmed, they may be attached to a glass surface and gang molds made so that it is possible to make several casts of one letter at one time.

Use empty shoe boxes to set up a stock pile of letters.

Painting and Installing 3-D Letters

Homemade plaster letters and commercially available plaster, plastic, and cardboard letters can be sprayed easily with a spray gun, airbrush, Flit gun, or with spray cans of paint. The letters are pressed to drafting tape which is mounted on scrap board with the sticky side up. This process makes it possible to paint the letters without the necessity of holding them in the hand. It also provides a quick indication of the space the label will occupy.

To put up a label of three-dimensional letters, tape a yardstick to the background as a guide. (Be sure the yardstick is not warped.) Use a carpenter's level to be sure the stick is straight. When starting a new line, leave at least the height of the letters as a space between lines; in other words, for 1/2-inch letters, leave at least a 1/2-inch space

between the *bottom* of the top line and the *top* of the next line. Actually, a proportion of one and a quarter of the letter height is better, or a space of 5/8-inch for 1/2-inch letters. Lines should be *not longer* than fifty to sixty characters.

Apply a thin thread of white glue to the back of the 3-D letters and press them against the label surface, using the taped-up yardstick for a horizontal guide.

OTHER THAN THREE-DIMENSIONAL

(Portions of this section originally were published by the American Association for State and Local History, Leaflet 22)

Group and specimen labels may be typeset, but the cost usually is prohibitive. If it is possible to purchase a used display-sign press from a local department store, slowly build up a stock of type, read the Boy Scout Merit Badge booklet on printing, and persuade the town printer to donate consultant advice to the museum (circumstances that have occurred in at least one museum) it might be practical to produce typeset labels. Less effort is involved in typing the labels with a machine equipped with bulletin-sized type, or in mastering hand lettering. If purchase of a label typewriter is considered, be sure to choose one which is provided with both upper and lower case letters. Labels which are typed only in caps quickly become difficult for the eye to read. The Royal typewriter company can supply a typewriter provided with 24-point size *bulletin* type which is excellent for most purposes. Check also to learn if an oversize carriage is available.

The specimen labels should be printed, typed, or lettered on paper of the same color as the background of the case. Labels that are on cards of a different color simply create twice as many objects in the case competing for attention. It is easy to match paper to the case.

Soak ordinary wrapping paper (Kraft, not slick or coated paper) for about five minutes in warm water. Remove and drain the paper, turning each edge up until it has drained from all four corners. Place it on plyboard or an old drawing board and use a squeezed-out sponge to dampen the wood around the edge of the paper. Tape down all four edges with gummed paper tape. Lap the tape about three-quarters of an inch over the edge of the paper. The paper will be quite wrinkled, but as it dries it will pull tight and smooth. When the case and case furniture are painted, this paper should also be painted. Use a latex or some other matte-finish paint that is waterproof when dry. The paper again will wrinkle, but when it has dried it will be tight and smooth once more.

Cut it from the board and print, type, or letter the label onto it. When the ink is dry, trim the labels and glue or dry-mount them in place. To glue them, soak the printed and trimmed labels for a moment in lukewarm water, then blot between lint-free towels. Put the label face down and brush the back with slightly thinned white liquid glue brushing from the center out to all edges. Put the label in place (on Easy-Curve, poster board, Masonite, etc.), cover it with a sheet of waxed paper, and use a linoleum brayer or any other rubber roller to press the label to the support and force out trapped air bubbles. Put fresh waxed paper over the surface, cover the label with a flat, texture-free panel (such as Masonite), and weight it down. Let dry overnight. It is a good idea to mount a sheet of wrapping paper on the back side of the label (following the steps just given) to counteract the pull of the label-paper as it dries. When both sides have been covered, the label should be flat and smooth and ready to install in the case. Dry-mounting may be accomplished with a pressing iron turned to low (linen) and by using dry-mounting tissue available from photography stores. A low-melting point, wax-based tissue is easiest to use. A third method of mounting the printed label to a support is to use a sheet of double-coated pressure-sensitive adhesive. This is a thin sheet of paper which is sticky on both sides. Covered with a protective sheet on each side, the sheet may be trimmed to approximate size, one side of the protective layer removed and the label pressed down to the adhesive. Final trimming of both the label and the adhesive sheet to which it is attached may then be done. The label is put in place by removing the protective sheet from the back of the adhesive and pressing the label to the surface. Each placement must be accurate, there will be no way of lifting, sliding, or adjusting the label. The advantage of using this material over the other two methods described is that the adhesive permanently mounts labels to glass and metal.

Lettering for Labels

Instant lettering, a fairly recent development in art materials, can be used to produce professional appearing labels. Called a dry transfer method, letters are printed on translucent plastic sheets. The sheet is placed on the label paper and the desired letter is rubbed gently. The letter transfers from the plastic to the label paper. Many sizes and styles of letters are available.

Stencils often may be found in local ten-cent, stationery, and drug stores. These are simple to use and effective in appearance if the letters are completed by filling in. Some styles and sizes are shown on following pages.

Gummed paper letters, from 1/4-inch to much larger, are inexpensive and easy to use. To apply, a straight-edge is taped or a line drawn on the label paper and tweezers are used to touch each letter to a slightly dampened sponge and then to put in place.

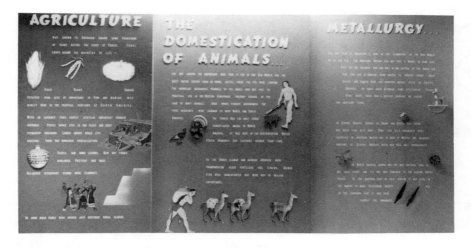

Large letters: plaster cast in latex molds; small letters, gummed paper.

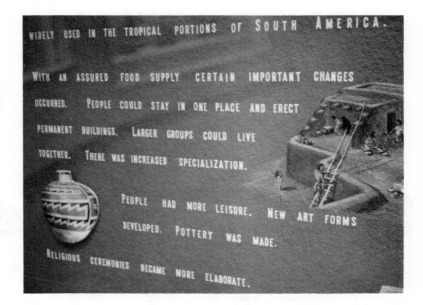

Close-up of gummed paper letters.

1 inch Roman Caps: letter segments connected and filled in

LETTER

3/4 inch Gothic Caps: letter outlines traced
guide line and space marks above

are available

3/4 inch Gothic Lower Case: letter segments outlined and
filled in; connecting lines drawn;
guide line and spacing marks above

IN MANY

SIZES AND

STYLES 1/2 inch Roman Caps

162

Specimens in some exhibits have labels made with a plastic typewriter which presses letters into an adhesive plastic strip. This method is acceptable for a limited quantity of labels.

Hand Lettering

Extensive lettering can be done with lettering guides (LeRoy, Wrico, Rapidesign, Rapidoguide), or by free-hand lettering. Hand-lettered labels may be prepared with the aid of these tools and materials:

T-square; drawing board; triangles; style B and D Speedball pen points in penholders; black *waterproof* drawing ink; an ordinary No. 2 lead pencil; art gum eraser, and paper that matches the color of the case.

Do not trim the colored paper to final size until the lettering is complete. It will be easier to fit letters on a size allowing for variation rather than to work on the final size. Try to handle the sheet by the edges and, as you work, protect the surface with a clean piece of paper under both hands. If grease from the natural oils in your hands gets on the surface of the paper it will be difficult for the ink to flow on smoothly.

Tape the colored paper on your drawing board with drafting or masking tape. Use the T-square and a triangle to lay out a series of guide lines, drawing the lines with very light strokes of your pencil. With very light marks, lay out the lettering of the label to check the spacing, then use the desired pen point, holder, and black ink to letter the label. Finally, when the ink is thoroughly dry, erase the pencil marks with the art gum eraser.

As with the 3-D letters, try to leave at least the height of the letters as a space between lines.

The guide lines will be easier to draw if you drill a series of holes in one of the triangles to use as guide holes. Use a 1/16-inch drill bit, then use a larger bit part way through the plastic to make a tapered hole.

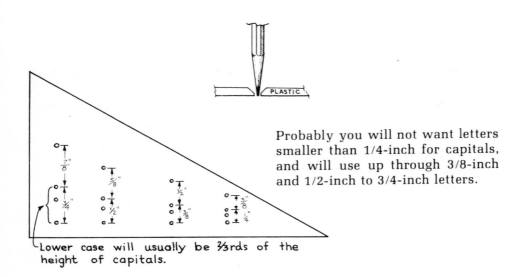

Probably you will not want letters smaller than 1/4-inch for capitals, and will use up through 3/8-inch and 1/2-inch to 3/4-inch letters.

Lower case will usually be ⅔rds of the height of capitals.

Use three-dimensional letters for any letters 3/4-inch and larger in size.

Use the T-square to guide the triangle across the paper. Draw the first series of lines, then line up the top hole with the bottom line and draw three more lines. Continue on down the page.

Drawing the Letters

You will be able to make all letters, both capitals (A) and lower case (a) with combinations of the six basic strokes shown below.

Two typical alphabets are shown here. The one to the right is made with the style B round-tip, Speedball pen point.

The alphabet to the left is made with the style D oval-tip, Speedball pen point.

Make a series of guide lines on a clean paper. Tape a sheet of tracing paper over the lines and practice the alphabets until it is possible to draw every letter from memory. The C, G, O, and Q will be easier to draw and will look better if they are drawn as wide ovals rather than true circles. An excellent and inexpensive booklet, prepared by the makers of Speedball pen points, may be obtained from most art supply, office supply, or stationery stores. The key to even, uniform, and effective hand lettering is *practice*.

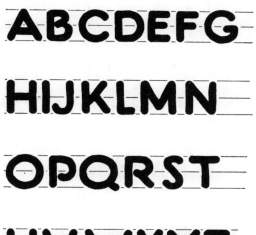

Basic strokes

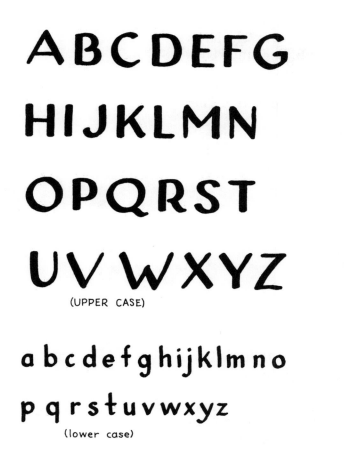

ABCDEFG
HIJKLMN
OPQRST
UVWXYZ
(UPPER CASE)

abcdefghijklmno
pqrstuvwxyz
(lower case)

ABCDEFG
HIJKLMN
OPQRST
UVWXYZ
(UPPER CASE)

abcdefghijklmno
pqrstuvwxyz
(lower case)

Points to Notice

The letters do not all fit into the same width. Compressing a wide letter, such as an M or W to fit into the same width as a narrow letter such as J or S will make the wide letter appear darker, or heavier than the rest of the letters in the word. Stretching a narrow letter to fit the space of a wide letter will make it appear skinny or lighter than the rest of the word.

Only these letters just touch both the top and bottom guide lines: B, D, E, F, H, I, K, M, N, P, R, T, X, Y, Z.

Because of an optical illusion the remaining letters are drawn as noted, to make them *appear* to be the same height as the other letters.

The point of the letter A extends just a little above the top line, while the legs rest on the bottom.

The top of the letters J, U, V, and W touch the top guide line, but extend just a little below the bottom line.

The round letters C, G, O, Q, and S extend a little beyond both the top and bottom lines.

The middle bars or lines of a letter vary in height. If all were placed on the true center some would appear high and others low. The letters A, G, P, and R have bars just a little *below* center; B, E, F, and H have bars a little *above* center.

On some letters it is a good idea to have the upper part a little smaller than the lower, to keep them from appearing top heavy. These are: B, G, K, R, S, X, Z.

One of the most frequent mistakes made by amateurs in lettering labels or signs is the mixing of capitals and lower case letters within a single word. Another is to make the slant of the N in the wrong direction; a third is the reversal of the S.

PROMINENT FAMILIES
OF MIDDLETOWN

Spacing Between Letters

Because letters carry different *optical* weights, they will not appear properly spaced if they are placed on a line so that each letter occupies exactly the same area, or with exactly the same distance between each letter within the word. If a measuring unit is established which is half again as wide as the letter I is thick, it can be used to show the correct *proportional* spacing between letters to achieve the correct visual balance.

LOCAL HISTORY
LOCAL HISTORY

Use half of this space when the letters A, L, T, V, W, and Y are followed by a straight vertical.

AN, LETTER,

VIE, WIN, YEA

Wedge-shaped letters occurring together, such as A, V, and W, should be kept a full space apart *on the diagonal*.

AWE, VASE

When the round letters C, D, G, O, Q, and S come next to a straight vertical or occur together, they are placed closer together than the space between two straight vertical letters.

IDIOM

When the letter A is preceded or followed by T or Y, the bottom of the A comes directly under the top of the T or Y. When A follows P the bottom of the A comes directly under the curved part of the P.

HAY, YAK,

TAP, PAT

When the letter L is followed by T, V, W, or Y the lower right hand corner of the L is directly under the top edge of the other letter.

BELT, ELVES

ALWAYS

A letter which follows *open* letters such as C, E, F, G, K, and P, is placed closer to the open letters than to a straight vertical.

CIDER, FIG, KEG

Spacing Between Words

Use the letters M or W as a measuring unit between words.

Finishing Methods

Note: All nail holes, cracks, and spaces should be filled with spackling paste; rough places should be sanded smooth. All sanding should be done *with* the grain, not across it.

Upson board, Cellotex, or plyboard may be painted, covered with textures, or be covered with fabric. Plyboard may also be stained.

Paint

In general, flat or matte finish, water-thinned paints such as household latex or vinyl interior paints are used for all case exhibit purposes. Usually two coats are required.

Satin-finish oil-base enamels are used on walls and stands that are exposed to public touch. Two coats are applied over a primer-sealer coat.

Painting Plyboard

The grain of plyboard will show through as a definite pattern unless a primer-sealer is used before other finishes are applied. Paint stores can recommend specific products. One of the best is white-pigmented Firzite which may be put on with a brush or roller. The plyboard is sanded lightly with very fine (6/0) garnet paper when the Firzite has dried, then it is painted with final coats of latex or vinyl paint.

Staining Plyboard

Ready-mixed stains are made in many colors. Oil stains are easy to use. They should be applied before the wood is sealed. Use a 2-inch or 3-inch flat brush, spreading the stain with the grain. After ten or fifteen minutes wipe off the excess with a rag. A second coat may be applied if a deeper color is desired. Let the wood dry overnight, then seal with a coat of shellac. When the shellac has dried, rub lightly with fine steel wool to dull the gloss.

For an antique stain use an oil-based white-pigmented undercoat thinned with turpentine and brush over the surface. Wipe off with a dry cloth after about ten to fifteen minutes. When dry, sand lightly with fine sandpaper. Seal with thinned white shellac (mix about half-and-half with denatured alcohol). Sand again when dry. Use a thinned flat enamel or tinted undercoat in whatever color desired to wipe on a second color. Let wood dry completely, then seal with one coat of a satin-finish varnish.

Adding Textures to Exhibit Surfaces

Texture paint, which comes as a powder and is mixed with water, may be purchased and applied with a variety of rollers to get differing finishes.

A flock (velvet-like) texture is obtained by spraying the flock particles over a wet, freshly painted surface. Flat-finish enamel is used for a base color-and-adhesive coat. Most vacuum cleaners have flock-guns available as an accessory. At Christmas time many Sno-Flock kits include a vacuum-cleaner powered flock gun. Different colors of flock are available from craft supply houses.

A base color-adhesive coat of flat enamel is also used if a layer of sand, gravel, ground cork, used coffee grounds, sawdust, or other texture is desired. These textures may be left their natural colors or spray-painted.

Fabrics may be stretched over a panel and stapled to the back. The material should be folded at least once along the stapled edges. A light spray-mist of water will shrink the cloth enough to pull it smooth.

Cloth may be more permanently attached by applying latex paint over the stretched fabric surface. Use a roller and work the paint well into and through the cloth. The material may sag and wrinkle while it is wet, but usually will tighten as it dries.

A loose-woven fabric such as decorative burlap or monk's cloth may be stretched over a panel of peg-board so that the pattern of peg-board holes is not apparent but the useful qualities of the board are not lost.

Appendices

Record Keeping

A record should be made of each exhibit. This may be kept on file cards or in a looseleaf notebook. The following information should be included in each exhibit's record:

1. Date exhibit completed;
2. Colors used: name of manufacturer, color name *and* formula. (It is a good idea to paint a brush-width swatch of each color next to each color notation.)
3. Manufacturer's names and addresses, and model numbers of any "special effects" used (automatic slide projectors, turntables, light color filters, etc.);
4. Name of manufacturer and specific kind of light (*very* important for fluorescent lights);
5. List of catalogue numbers of each specimen in the exhibit;
6. A full copy of labels in the case together with main bibliographic references;
7. List of references for any drawn or painted illustrations;
8. List of negative numbers of any photographs used.

Regional Conservation Centers

Balboa Art Conservation Center
P.O. Box 3755
San Diego, CA 92103

Center for Conservation and Technical Studies
Fogg Museum, Harvard University
32 Quincy Street
Cambridge, MA 02138

Conservation Center for Art & Historic Artifacts
264 South 23 Street
Philadelphia, PA 19103

Division for Historic Preservation
New York State Parks & Recreation
Peebles Island
Waterford, NY 12188

Intermuseum Conservation Association
Allan Art Building
Oberlin, OH 44074

Northeast Document Center
Abbott Hall
24 School Street
Andover, MA 01810

Pacific Regional Conservation Center
1355 Kalihi Street
P.O. Box 1900-A
Honolulu, HI 96819

Rocky Mountain Regional Conservation Center
University of Denver
2420 South University Boulevard
Denver, CO 80208

Williamstown Regional Art Conservation Center
Clark Art Institute
225 South Street
Williamstown, MA 02167

Upper Midwest Conservation Association
The Minneapolis Institute of Arts
2400 Third Avenue South
Minneapolis, MN 55404

Useful Resources and Publications

One of the best references for *general carpentry* is the Reader's Digest *Complete Do-it-yourself Manual, 1973*. The first three sections, "Hand tools: How to choose and use them," "Power tools for the home workshop," and "Fasteners, hardware and adhesives" are invaluable. Construction details given for such things as wall building, door framing, cabinet construction, etc. often can be adapted for museum installations.

The annual Directory of the American Association of Museums now regularly includes a section listing "Materials and Suppliers." This list is revised and updated each year the directory appears.

American Association of Museums
1055 Thomas Jefferson Street, N.W.
Washington, DC 20007

The museum Reference Center at the Smithsonian Institution is a marvelous source, providing information about publications in, about, by, and for the museum profession. At least forty bibliographies are now available. The bibliography on museum exhibits is extensive. Sometimes it is possible to obtain copies of journal articles which are difficult, if not impossible, to find elsewhere.

Museum Reference Center
Office of Museum Programs
Arts and Industries Building, Room 2235
Smithsonian Institution
Washington, DC 20560

The American Association for State and Local History probably has published more useful texts for the museum profession than any other organization. Their offerings vary from books and booklets to an extensive series of technical leaflets. Books covering different aspects of exhibit methods are:

Harris, Karyn Jean. *Costume Display Technics.*
Neal, Arminta. *Exhibits for the Small Museum.*
Serrell, Beverly. *Making Exhibit Labels.*

A series of twenty-four technical leaflets is listed as "Exhibit series (506)."

A current catalogue of the AASLH Press may be requested from:

American Association for State & Local History
172 Second Avenue, North
Suite 102
Nashville, TN 37201

While some of the following publications are now out of print, it should be possible to see most of them by borrowing through an inter-library loan.

Arnheim, Rudolf. *Art and Visual Perception*. University of California Press, Berkley and Los Angeles, Calif., 1960.

Baker, Frank and Edward S. Morse. *Visual Communications: International*. Communication Arts Books; Hastings House, Publishers, N.Y., 1961.

Bernard, Frank J. *Dynamic Display*. Display Publishing Co., Cincinnati, Ohio, 1952.

"Big Leisure-Time Explosion," in *Popular Gardening and Living Outdoors*, Spring 1968. Holt, Rinehart and Winston, Inc., N.Y.

Birren, Faber. *Selling with Color*. McGraw-Hill, N.Y., 1945.

———. *Color, Form and Space*. Reinhold Publishing Corp., N.Y., 1961.

Black, Mischa, ed. *Exhibition Design*. Architectural Press, London, 1950.

Borgwardt, Stephanie. *Library Display*. Witwatersrand University Press, Johannesburg, South Africa, 1960.

Brawne, Michael. *The New Museum: Architecture and Display*, Frederick A. Praeger, N.Y., 1965.

———. *The Museum Interior: Temporary and Permanent Display Techniques*. Architectural Book Publishing Company, N.Y., 1982.

Buckley, Jim. *The Drama of Display*. Pellegrini & Cudahy, N.Y., 1953.

Burns, Ned. *Field Manual for Museums*. National Park Service, Washington, D.C., 1941. (Out of print.)

Butkowski, Patricia. *A Look You'll Like in Labels*. Detroit Historical Society, Detroit, Mich., 1960.

Campbell, Robert and N.H. Mager. *How to Work with Tools and Wood*. Pocket Books, Inc., N.Y., 1965.

Carmel, James. *Exhibition Techniques*. Reinhold Publishing Co., N.Y., 1962.

Casterline, Gail Farr. *Archives & Manuscripts: Exhibits*. Society of American Archivists, Chicago, 1980.

Coleman, L.V. *The Museum in America*. (3 Vols.) American Association of Museums, Washington, D.C., 1939.

———. *Museum Buildings*. American Association of Museums, Washington, D.C., 1950.

Communicating with the Museum Visitor: Guidelines for Planning. Royal Ontario Museum, Toronto, Canada, 1976.

Cummings, Carlos. *East is East and West is West*. Buffalo Museum of Science, Buffalo, N.Y., 1940.

Dair, Carl. *Design with Type*. Pellegrini & Cudahy, N.Y., 1952.

Dale, Edgar. *Audio-Visual Methods in Teaching*. Dryden Press, N.Y., 1954.

Daniels, George. *How to be Your Own Home Electrician*. Popular Science Publishing Co., Harper & Row, N.Y., 1967.

DeCristoforo, R.J. *How to Build Your Own Furniture*. Popular Science Publishing Co., Harper & Row, N.Y., 1967.

Dennison Flower Book. Dennison Mfg. Co., Framingham, Mass., 1959.

Dreyfuss, Henry. *Designing for People*. Simon and Schuster, N.Y., 1955.

———. *The Measure of Man*. Whitney Library of Design, Whitney Publications, Inc., N.Y., 1960.

Exhibition Techniques. New York Museum of Science and Industry. Rockefeller Center, N.Y., 1940.

Flesch, Rudolf. *The Art of Readable Writing.* Harper & Bros., N.Y., 1949.

Gaba, Lester. *The Art of Window Display.,* Studio Publications, Thos. Y. Crowell Co., N.Y., 1952.

Gardner and Heller. *Exhibition and Display.* F.W. Dodge Corp., N.Y., 1960.

Garrett, Lillian. *Visual Design.* Reinhold Publishing Corp., N.Y., 1967.

Guthe, Carl. *So You Want a Good Museum.* American Association of Museums, Washington, D.C., 1957.

Harris, Karyn Jean. *Costume Display Techniques.* American Association for State and Local History, Nashville, Tenn., 1977.

Harrison, Raymond O. *The Technical Requirements of Small Museums.* Technical Paper No. 1, Canadian Museums Association, Ottawa, Ontario, 1966.

Hayett, William. *Display and Exhibit Handbook.* Reinhold Publishing Corp., N.Y., 1967.

Horn, George F. *Bulletin Boards.* Reinhold Publishing Corp., N.Y., 1962.

Kapp, Reginald O. *The Presentation of Technical Information.* Macmillan Co., N.Y., 1948.

Kane, Lucile M. *A Guide to Care and Administration of Manuscripts.* American Association for State and Local History, Nashville, Tenn., 1966.

Leroi-Gourhan, A. *Prehistoric Man.* Philosophical Library, N.Y., 1957.

Lohse, Richard P. *New Design in Exhibitions.* Praeger, Inc., N.Y., 1954.

Lonberg-Holm and Sutnar. *Designing Information.* Whitney Publications, Inc., N.Y., 1947.

Longyear, William. *Type and Lettering.* Watson-Guptill Publications, Inc., N.Y., 1965.

Low. *The Museum as a Social Instrument.* American Association of Museums, Washington, D.C., 1942.

Luckiesh, M. *Visual Illusions.* Dover Publications, Inc., N.Y., 1965.

Manual of Exhibit Properties. Detroit Historical Museum. Detroit, Mich., 1961.

Marshall, William E. and Robert L. Damm. *The Museum Exhibit.* Ohio Historical Society, Ohio State Museum, Columbus, Ohio, 1959.

Miles, R.S., with M.B. Alt, D.C. Gosling, B.N. Lewis and A.F. Tout. *The Design of Educational Exhibits.* George Allen & Unwin, London, 1982.

Miller, Jan B. *AMPHOTO Guide to Framing & Display.* AMPHOTO, N.Y., 1980.

Neal, Arminta. *Exhibits for the Small Museum: A Handbook.* American Association for State and Local History, Nashville, Tenn., 1976.

———. "New Uses for Styrofoam Plastic in Museum Display" *Curator,* Vol. 5, No. 2, 1962, American Museum of Natural History, N.Y.

Nelms, Henning. *Thinking with a Pencil.* Barnes & Noble, Inc., N.Y., 1974.

Nelson, George. *Display.* Whitney Publications, N.Y., 1953.

The Organization of Museums: Practical Advice. UNESCO: Columbia University Press, New York, N.Y., 1960.

Osborn. *Manual of Traveling Exhibitions.* UNESCO: Columbia University Press, New York, N.Y., 1953.

Panero, Julius. *Anatomy for Interior Designers*. Whitney Publications, Inc., New York, N.Y., 1962.

Parker, Donald Dean. *Local History: How to Gather it, Write it, and Publish it*. Social Science Research Council, New York, N.Y., 1944.

Parr, A.E. *Mostly about Museums*. American Museum of Natural History, New York, N.Y., 1959.

Picture Framing and Wall Display. Lane Publishing Co., Menlo Park, Calif., 1979.

"Planning Museums and Art Galleries," *Museums Journal*, Vol. 63, Nos. 1 & 2, June-September, 1963. The Museums Association, London, England.

Pond, Gordon G. *Science Materials: Preparation and Exhibition for the Classroom*. William C. Brown Co., Publishers, Dubuque, Iowa, 1959.

Publications in Museology:

No. 1 *A Bibliography of Museums and Museum Work, 1900-1960*. Stephan F. de Borhegyi and Elba A. Dodson.

No. 2 *A Bibliography of Museums and Museum Work, 1900-1961, Supplement*. Stephan F. de Borhegyi, Elba A. Dodson, and Irene A. Hanson.

No. 3 *The Museum Visitor*. Stephan F. de Borhegyi, Irene A. Hanson, eds.

Milwaukee Public Museum, Milwaukee, Wisc.

Randall, Reino and Edward C. Haines. *Bulletin Boards and Display*. Davis Publications, Inc., Worcester, Mass., 1961.

Rowe, Frank A. *Display Fundamentals*. The Display Publishing Co., Cincinnati, Ohio, 1965.

Schwartz, Alvin. *Museum*. E.P. Dutton & Co., Inc., N.Y., 1967.

Science on Display: A Study of the United States Science Exhibit, Seattle World's Fair, 1962. Institute for Sociological Research, University of Washington, Seattle, Wash., 1963.

Serrell, Beverly. *Making Exhibit Labels*. American Association for State and Local History, Nashville, Tenn., 1983.

Sharpe, Grant W. *Interpreting the Environment*. John Wiley & Sons, Inc., N.Y., 1976.

Shelley, William J. *Paper Sculpture in the Classroom*. Fearon Publishers, San Francisco, Calif., 1957.

Silvestro, Clement. *Organizing a Local Historical Society*. American Association for State and Local History, Nashville, Tenn., 1959.

Smith, Paul, ed. *Creativity*. Communication Arts Books, Hastings House, Publishers, N.Y., 1959.

Sutnar, Ladislav. *Visual Design in Action*. Hastings House, N.Y., 1961.

Talmadge, R.H. *Point of Sale Display*. The Studio Publications, N.Y., 1958.

Taylor, Francis Henry. *Babel's Tower*. Columbia University Press, N.Y., 1945.

Tyler, Barbara and Victoria Dickenson. *A Handbook for the Travelling Exhibitionist*. Canadian Museums Association, Ottawa, Ontario, Canada, 1977.

Witteborg, Lothar P. *Good Show! A Practical Guide for Temporary Exhibitions*. Smithsonian Institution Traveling Exhibition Service, Washington, D.C., 1981.

Wittlin, Alma. *The Museum: Its History and its Tasks in Education*. Routledge and Kegan Paul, Ltd., London, England, 1949.